PAST PRESENT

ARKANSAS CITY

Opposite: Arkansas City's first permanent high school was built in 1890. Robert Baird, brother of pioneer resident Thomas Baird, led construction workers. He was assisted by expert stonecutter Joseph Bossi, from Milan, Italy. Locally quarried Silverdale stone was used to build the Richardsonian Romanesque structure. The high school operated there from 1892 until 1922. It later became a sixth-grade center, a USO (United Service Organization) during World War II, and a "Teen Town" recreation center. Today, Cowley College operates the building as Ireland Hall. (Courtesy Terry Naden.)

Past & Present

ARKANSAS CITY

Foss Farrar

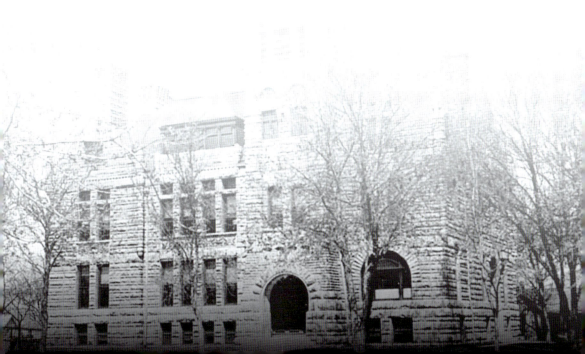

To the memory of Otis Morrow, a lawyer, town leader, and friend. His tireless work for the benefit of Arkansas City and its citizens inspired many people, including me.

Copyright © 2024 by Foss Farrar
ISBN 978-1-4671-6195-4

Library of Congress Control Number: 2024938482

Published by Arcadia Publishing
Charleston, South Carolina

Printed in the United States of America

For all general information, please contact Arcadia Publishing:
Telephone 843-853-2070
Fax 843-853-0044
E-mail sales@arcadiapublishing.com

Visit us on the Internet at www.arcadiapublishing.com

ON THE FRONT COVER: The heart of Arkansas City's downtown is shown in contrasting images—one of a dirt street with crude-looking wood structures erected in the town's pioneer days of the early 1870s, and the other of attractive commercial buildings, including a renovated 1920s theater serving as a downtown anchor. Arkansas City grew quickly from a rustic frontier town into a commercial center with handsome stone and brick buildings by the 1880s. (Past, courtesy University of Kansas Spencer Research Library; present, photograph by Foss Farrar.)

ON THE BACK COVER: This 1913 photograph shows automobiles belonging to members of a visiting motor club parked in front of the Carnegie Library on West Fifth Avenue. Shown at right is the First Methodist Church across the street on South Second Street. (Courtesy Kansas State Historical Society.)

Contents

Acknowledgments vii
Introduction ix
1. Downtown 11
2. Business and Industry 35
3. Churches and Schools 69
4. Parks and Homes 85

Acknowledgments

Without the help of many people who share an interest in the history of Arkansas City, this book could not have been written. First, I would like to thank my fellow photographers of current scenes to match the vintage photographs and postcards in this book. Arkansas City Middle School teacher Lin Gardner (LG) spent many hours of her free time taking photographs, and retired educator Marge Hernandez (MH) also helped. I also appreciate the assistance of Bob Frazee, emergency management coordinator for the City of Arkansas City, for providing me access to industrial sites in town.

Current photographs by LG and MH are attributed to them in this book. Unless otherwise noted, all other present photographs appear courtesy of the author. A few of the past images also appear courtesy of the author unless otherwise stated.

Much of the research for this book came from the online archives of local newspapers the *Arkansas City Traveler* and the *Cowley Courier Traveler*. I accessed the archives from the Arkansas City Public Library website and did further research using library materials. I would like to thank library director Mendy Pfannenstiel for her help with these resources. My late friend and fellow history devotee Wilbur Killblane (WK) deserves special mention for providing me with dozens of meticulously organized notebooks containing copies of newspaper articles detailing Arkansas City's history.

The administrators and staff of several museums, research libraries, and historical societies deserve my special thanks. They provided help accessing and scanning many of the vintage photographs that appear in this book. Some of the earliest photographs of Arkansas City are from the Otis Morrow-Jean Lough Collection at the Kenneth Spencer Research Library of the University of Kansas, Lawrence (SRL). I would like to thank the library's head of public services, Caitlin D. Klepper, for her assistance, and Kathy Lafferty, copy services manager/reference at the library. I also appreciate the assistance of Lisa Keys of the State Archives Division of the Kansas State Historical Society (KSHS); Amy Jo McWhirt, administrator of the Cowley County Historical Society Museum (CCHSM); and Sandy Randel, who helped provide access to photographs at the Cherokee Strip Land Rush Museum (CSLRM).

I would also like to thank several friends who shared their photographs with me: Terry Naden (TN), Denah Spangler (DS), JoLynn Foster (JF), Steve Ross (SR), Larry P. Rhodes (LPR), Bill Docking (BD), Jann Ziegler (JZ), and my cousin Valerie Perkins (VP).

Finally, I extend my thanks to the close friends and family members who supported me throughout the months I spent working on this book and Arcadia Publishing for publishing it.

Introduction

Arkansas City's history is the story of a frontier town founded in 1870 on the northern border with Indian Territory that prospered quickly at the turn of the 20th century. It became an important trade center with flour mills, oil refineries, meatpacking houses, and other businesses and industries. Several railroads made daily stops in town, and it grew steadily. During the last decades of the 1900s, however, Arkansas City has lost several key industries and large stores, resulting in a business downturn. But new entrepreneurial businesses have opened recently. And there is increased activity to revive the downtown historical district. In addition, plans are underway to build a cultural and immersion center for museum displays and archaeological research on a historical city of Wichita people, named Etzanoa, that flourished between 1450 and 1750 in eastern Arkansas City.

This book provides a glimpse at that history by showing photographs of past street scenes and buildings next to current photographs of the same scenes. It is not within the scope of this book to cover a comprehensive history of the town. But within the limited space allowed for image captions, the author attempts not only to describe the building or scene, but also name some of the significant people who were associated with it.

Before a brief look at the town's history, the author would like to say a word about the pronunciation of Arkansas City and the river for which it was named. In south-central Kansas, it is pronounced Ar-KANSAS, not Arkan-SAW. Ar-KANSAS is how it has been pronounced since the town's founding.

Arkansas City—or "Ark City," as it is commonly called in southern Kansas—was first conceived in the minds of 15 men, most from Emporia, Kansas. Several of the adventurers trekked 119 miles south and west of Emporia to Osage Indian tribal land between the Arkansas and Walnut Rivers. The explorers included Civil War veterans, businessmen, and educators who planned to start a new town near the Kansas-Oklahoma border. When the pioneers arrived at the future townsite in early 1870, they had to be aware that the land they were scouting was Osage territory and that the Osage people were about to be removed to Indian Territory, just across the border a few miles away.

One of the first goals of the founders of Ark City was to bring railroad service to town. They began this effort during the year the town was founded, almost 10 years before the first train arrived, in December 1879. They gave land worth $50,000 to the Atchison, Topeka & Santa Fe Railroad for right-of-way. In 1889 and again in 1893, the town was flooded with people preparing to make runs for free land into Oklahoma Territory. Arkansas City was the largest departure point for the Cherokee Strip Land Rush of 1893. The town's population increased to between 50,000 and 100,000 people in the days before the run.

During the town's early years, waterpower was used to operate grain mills along the Walnut River. The largest waterpower project was the building of a canal in 1880–1881 that eventually

extended five miles. It flowed from the Arkansas River northwest of town to the Walnut River on the southeast. The development of electricity and the high costs of maintaining the canal caused it to be abandoned. In 1915, the Kansas Gas and Electric Company purchased the canal. In 1928, the company transferred ownership of the property to the city.

The downtown commercial district changed rapidly during the 1880s. The wood-frame buildings of the 1870s were replaced by elaborately constructed stone and brick buildings. There was a growth of business on South Summit Street between Adams and Fifth Avenues. In 1887, the first city building, a two-story structure with a spire-topped tower, was erected. Between 1910 and 1930, the town continued to boom with the discovery of oil in the Ark City area. In 1917, the first refinery was built, followed by a second in 1923. The oil boom reached its peak around 1925 and tapered off in the late 1920s and 1930s. During the 1920s, Ark City also was a base for early-day aviators. Among those flyers was Walter H. Beech, who became a founder of the Beech Aircraft Company in Wichita, Kansas.

The population of Arkansas City reached its high point in 1960 at 14,262. Between then and 2020, there was a gradual decline to 11,974. The downtown remained the primary location for finance and specialty retail shops for years, keying a regional retail hub. However, the renovation of older downtown buildings became a primary concern of community leaders, and it continues to be a local challenge to this day.

CHAPTER 1

DOWNTOWN

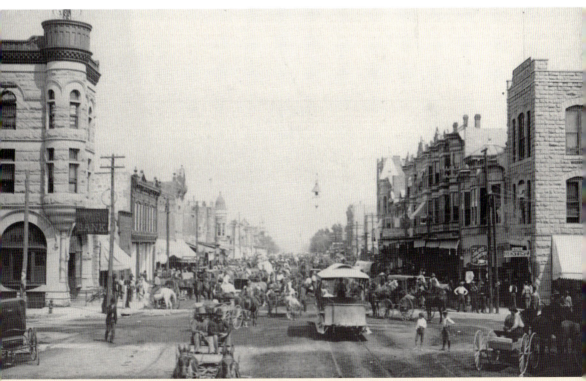

Arkansas City photographer P.A. Miller took this photograph from the corner of Summit Street and Washington Avenue around 1889 or 1893, when the population of Arkansas City temporarily increased by the thousands. The land seekers were preparing to participate in the Oklahoma land runs to race for free land in what had been Indian Territory. (Courtesy CCHSM.)

The west side of the 100 block of South Summit Street looked quite different in 1872 than it does today. The wood-frame structures of the early 1870s, when the town was being developed, were replaced by brick and stone buildings during the 1880s. Several of those structures seen in today's view of the west side of the 100 block of South Summit Street continue to house businesses. They include the Union State Bank building, originally the First National Bank, constructed in 1883. (Past, courtesy KSHS.)

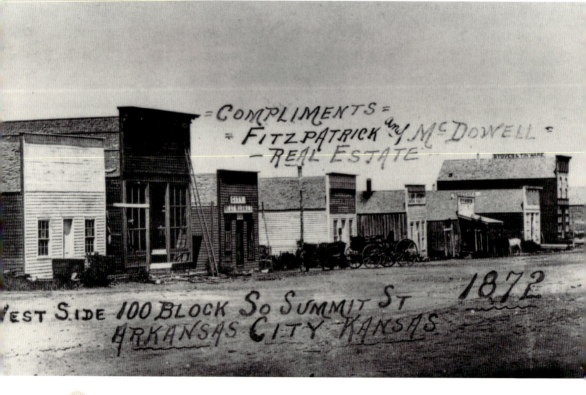

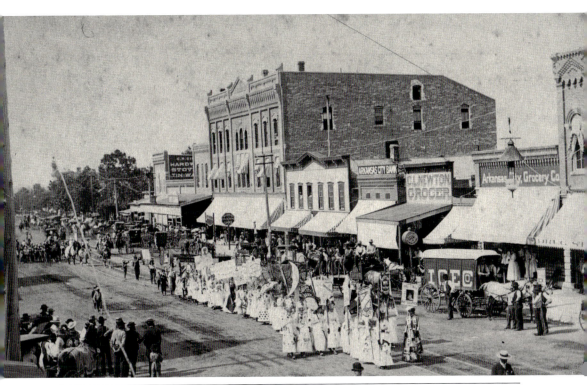

This historical photograph shows participants of a Trades Parade marching or riding horses in downtown Arkansas City. The photograph was taken by T. Croft, a turn-of-the-19th-to-20th-century Ark City photographer. It shows the 100 block of South Summit Street. The view is to the northeast from the west side of the street. Highland Hall, the three-story structure toward the left of the photograph, and adjacent structures were replaced in 1924 by the Burford Theatre and shops building.

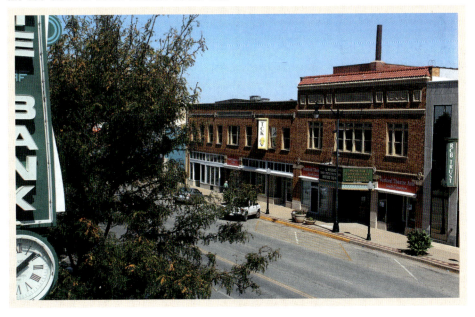

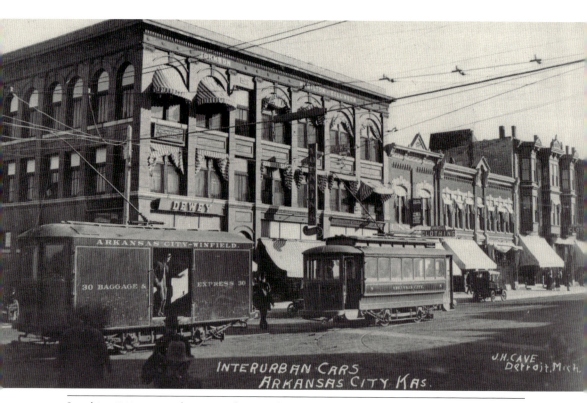

In this 1910s to early-1920s photograph, electric-powered interurban cars are stopped on Summit Street at its intersection with Fifth Avenue. Interurban service began in 1909 between Arkansas City and Winfield, a neighboring town to the north. The Johnson business structure, at left, replaced the former Colorado Building that was destroyed in a 1905 fire. Today, the Howard Building is where the Johnson Block once stood. Adjacent buildings replaced former ones destroyed in a 1931 fire. (Past, courtesy KSHS.)

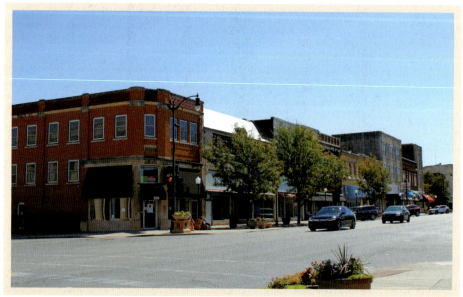

The Colorado Building, constructed in 1889, was the first of three multistory buildings at the southeast corner of the main intersection of town, Summit Street and Fifth Avenue. It burned down in 1905 and was replaced by the Johnson Block—later known as the Donohue Block—which also burned down in 1931. That same year, the Howard Building, shown today, was constructed. It is named for longtime Arkansas City newspaper editor and publisher Richard C. Howard. (Past, courtesy KSHS.)

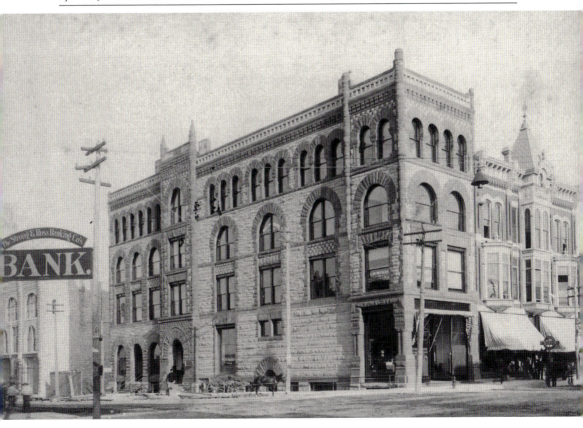

Downtown

Western photographer George Cornish recalled that before the town was developed in the early 1870s, the intersection of Fifth Avenue and Summit Street was just an immense sand hill. But by the early 1900s, Fifth Avenue rivaled Summit Street as the busiest street in town. In this view looking west on Fifth Avenue are buildings housing banks, offices, retail stores, and the magnificent Fifth Avenue Hotel, shown right in the far distance. Today, most traffic is on Summit Street.

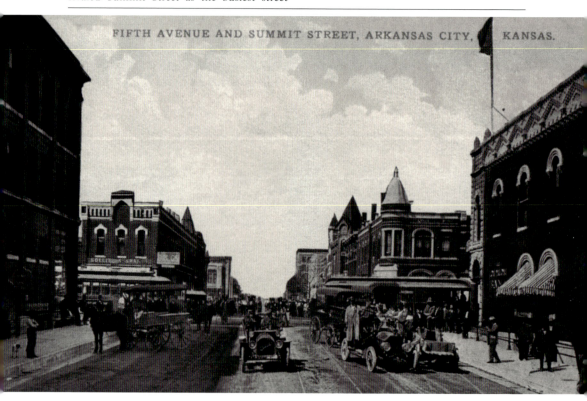

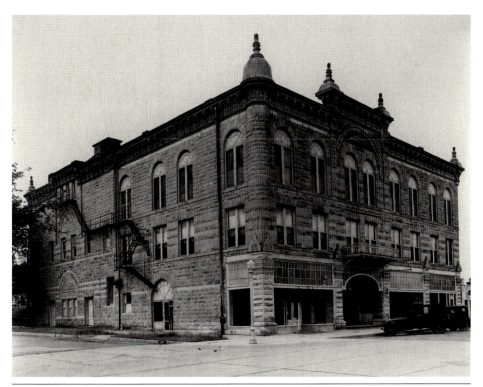

Town leaders in the late 1880s financed an elegant three-story opera house built of native stone. It opened in 1888 and was the venue for various kinds of live entertainment and civic events for more than 40 years. Its grand opening featured celebrated British actress Lillie Langtry performing the lead role in a dramatic play. Located on the southwest corner of Fifth Avenue and B Street, where the Arkansas City Recreation Center stands today, the opera house was demolished in 1943. (Past, courtesy SRL.)

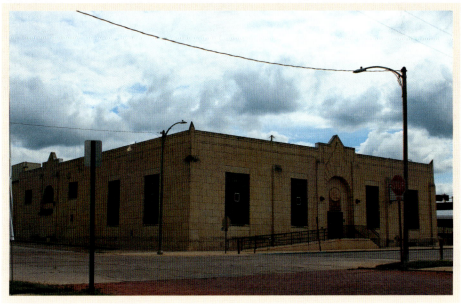

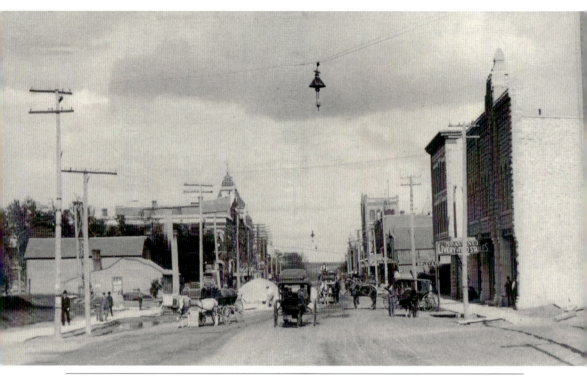

Fifth Avenue, in this view looking east from First Street in 1890, contrasts greatly with the same view today. The Fifth Avenue Livery barn shown at the front right in the historical photograph was a town landmark built in 1879 on property that Thomas Baird, a carpenter in the early days and later a farmer and banker, had owned. It was demolished in 1909. At the site today is the elegant 1924 Cornish photography building. (Past, courtesy KSHS.)

The Fifth Avenue Hotel was built in 1887 at the northwest corner of Fifth Avenue and Second Street. Built of Silverdale cut stone, it was funded by Arkansas City businessmen. Later called the Monroe Hotel, it was razed in 1944. Today, Cowley College's Galle-Johnson Hall is at the site. It opened in 1952 as a classroom building for the junior college. For the previous 30 years, the college had held classes in the basement of the high school.

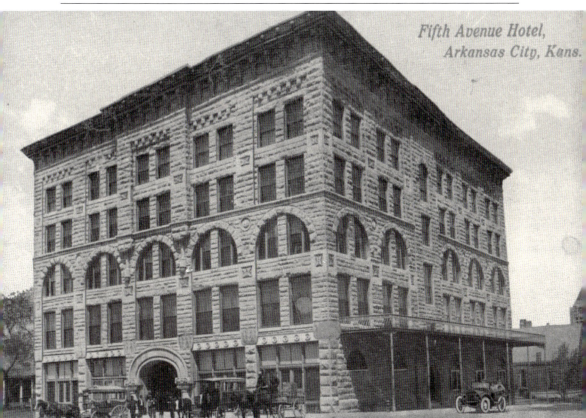

DOWNTOWN

This view of the 300 block of Summit Street is looking north. Arkansas City improved its downtown commercial district rapidly in the 1880s, building several handsome brick and stone structures on South Summit Street between Adams and Fifth Avenues. Some of the same buildings that appear in the early 1900s photograph remain standing today, although others were altered or destroyed by fires decades ago. Ark City's downtown district was listed in the National Register of Historic Places in 1983. (Past, courtesy KSHS.)

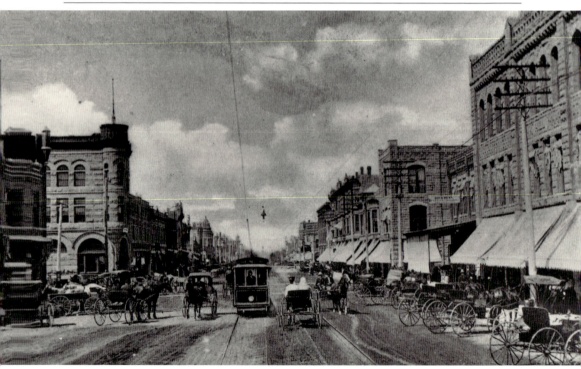

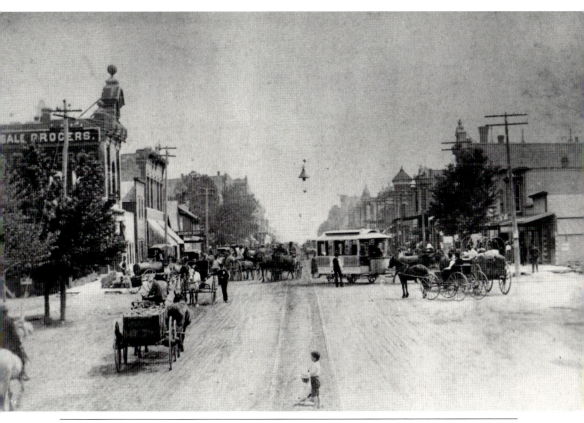

Dated 1890, this historical photograph shows a Summit Street scene looking south from just north of the corner of North Summit Street and Chestnut Avenue. The business building labeled "Wholesale Grocers," shown at left, today is replaced by a parking lot and drive-through for an automated banking machine. RCB Bank occupies the corner on the opposite side of the street. (Past, courtesy KSHS.)

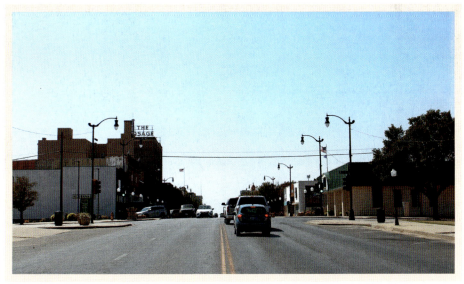

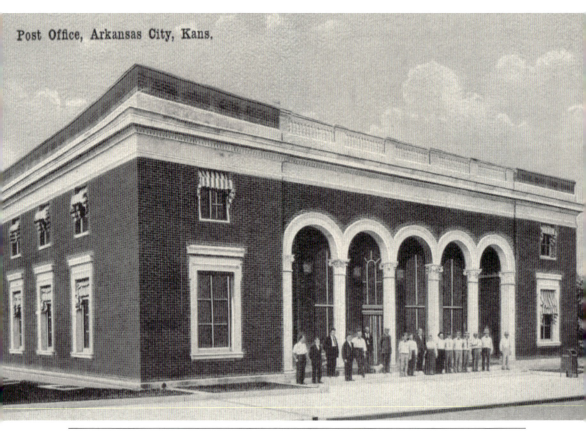

Post Office, Arkansas City, Kans.

Postal workers lined up after the newly dedicated US Post Office for Arkansas City was opened in 1915. Ark City's first post office was established in 1870 in a log cabin store. In 1875, it was moved downtown to the *Arkansas City Traveler* newspaper office building after editor Cyrus M. Scott had been appointed postmaster. In succeeding years, the post office was moved to several other locations. Today, the Arkansas City Public Library occupies this building.

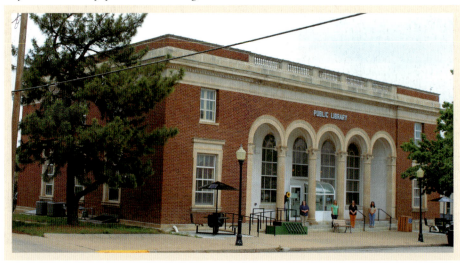

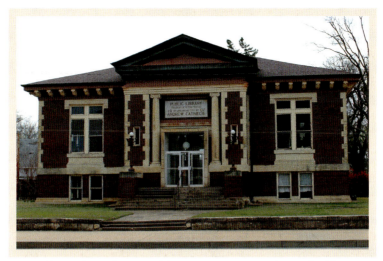

Arkansas City's first public library building was funded by philanthropist Andrew Carnegie. The Carnegie Library at Fifth Avenue and Second Street was dedicated in grand style in 1908. Keynote speaker A.J. Hunt told the large gathering that there was no more elegant building in town. The library occupied the structure until it was moved to the former post office building on East Fifth Avenue. Ark City merchant Roger Sparks purchased the building in 1986. (Past, courtesy CCHSM.)

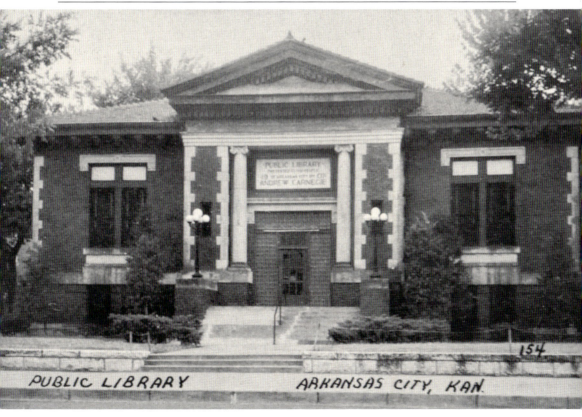

This mid-to-late-1920s photograph was taken from the southeast corner of South Summit Street and Jefferson Avenue. In the foreground are two business buildings that have been demolished and replaced by other structures today. At left is the former Syndicate Building that housed the Jitney Jungle grocery store. The Hill-Buick automobile dealership, at right, is now a motel building. (Past, courtesy DS.)

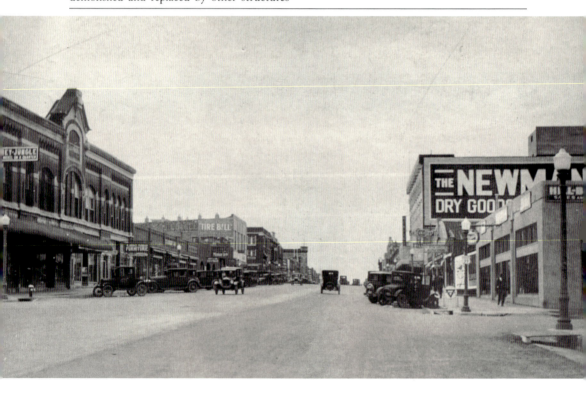

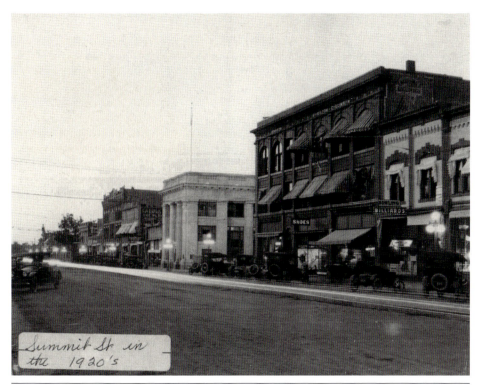

Summit St in the 1920's

The east side of the 100 and 200 blocks of South Summit Street are shown in this early 1920s photograph. The view is looking toward the northeast and shows the three-story Hamilton-Collinson building and the Home National Bank, opposite each other at the corner of Fifth Avenue and Summit. The Hamilton-Collinson building was destroyed in a 1931 fire. Highland Hall and Saddle Rock Café were replaced by the Burford building, as shown in the current photograph. (Past, courtesy WK; present, courtesy LG.)

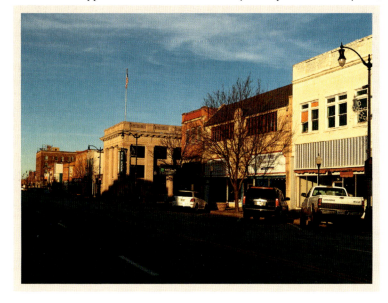

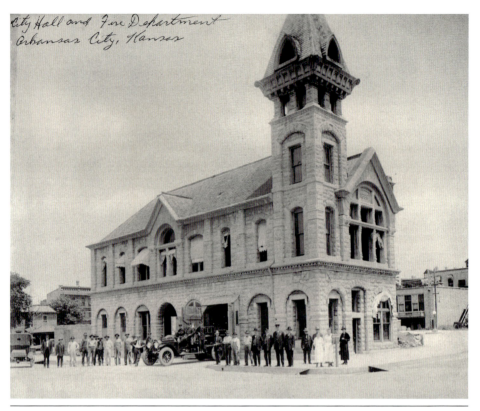

In the historical photograph, city employees pose in front of the old city hall building that was constructed in 1887. Located at the corner of First Street and Central Avenue, it was razed in 1919 after the new city hall was built on the site. The site also had been occupied by a coal yard, a livery barn, a blacksmith shop, and a machine repair shop. In the background at left is the three-story Elmo Hotel. It was razed in 1985 and is not visible in the current photograph of the scene.

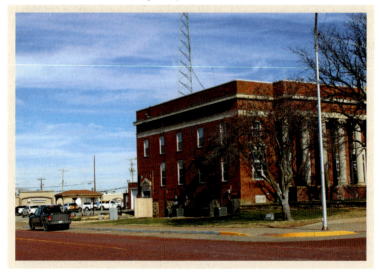

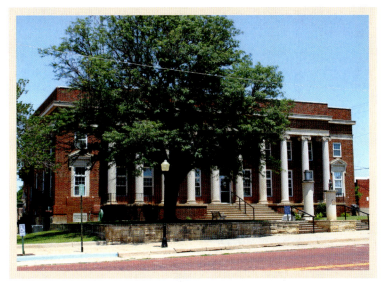

This image shows city hall at the corner of Central Avenue and First Street. It was built in 1919 and looks much the same today. It replaced the former city building, a stone structure on the same site, constructed in 1887. For many decades, the newer, stately looking building also housed the police and fire departments at its north end. The fire department was moved in 1980, and the police department moved across the street in 1997.

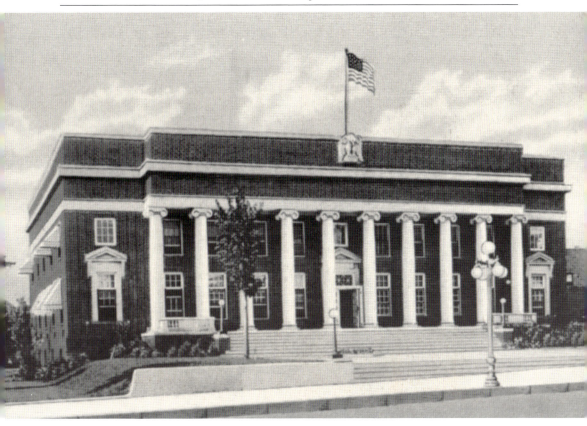

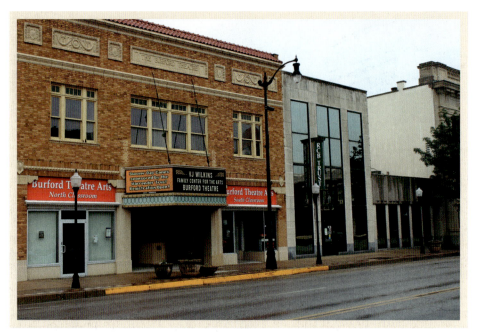

Children lined up in 1935 for free movies sponsored by civic leaders. The Burford Theatre opened in 1924 as a vaudeville movie palace. Today, after a 14-year-long community restoration effort, the Burford serves as a downtown anchor, bringing in residents and tourists for concerts, theater productions, movies and film festivals, art and music classes for children, and social events. (Past, courtesy LPR.)

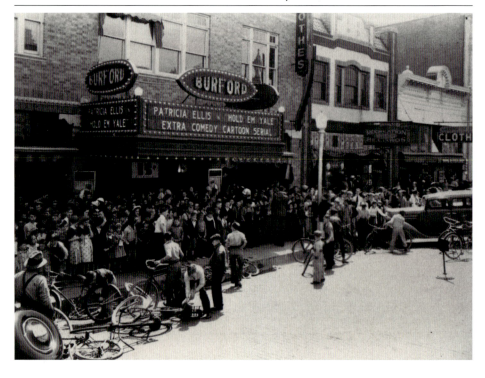

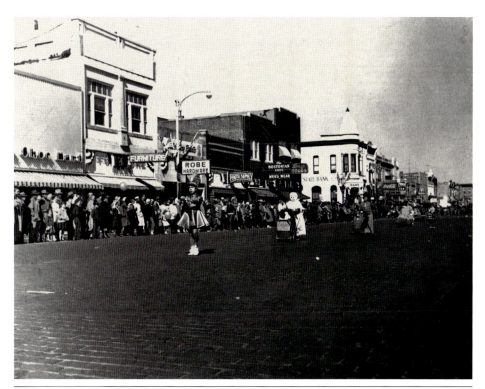

Children are shown marching south on Summit Street in downtown Arkansas City in this early-1950s photograph. The view is to the northwest from just south of the intersection of Summit Street and Fifth Avenue. The view looks much the same today, but the businesses housed in some of the buildings have changed. For instance, Long's Drug, shown left of the Union State Bank building, today is Taylor Drug. (Past, courtesy CCHSM.)

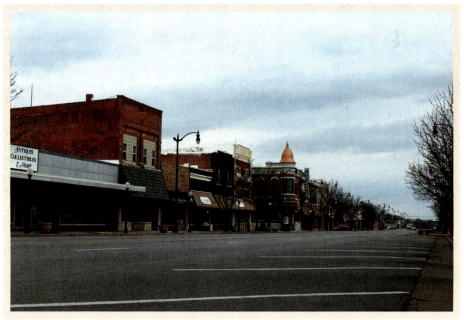

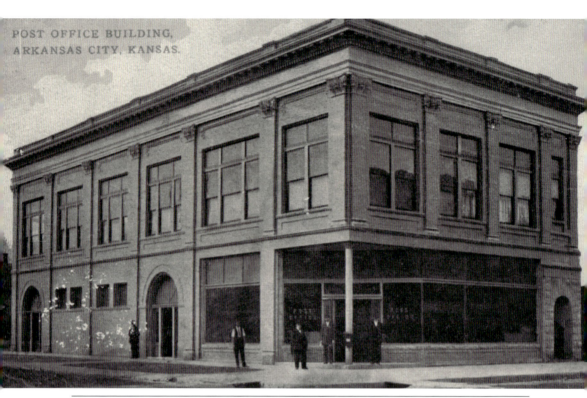

POST OFFICE BUILDING, ARKANSAS CITY, KANSAS.

The cornerstone of a new post office building at the corner of West Fifth Avenue and First Street was set on June 19, 1907. The post office occupied the ground level of the building until 1915, when a larger post office was constructed on East Fifth Avenue at A Street. When it was being planned a year earlier, the local lodge of the Independent Order of Odd Fellows (IOOF) arranged to use the upper floor for its meetings. The lodge had been seeking a place of its own and had arranged to use the top floor of the new post office building when it was planned in 1906. The old IOOF entrance can still be seen on the northwest corner of the building. Cowley County Community College purchased the building for a physical workout center in 1995. (Present, courtesy MH.)

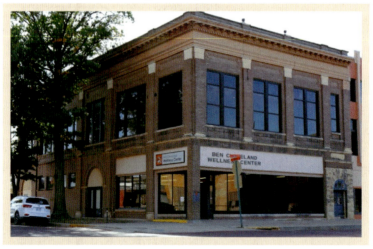

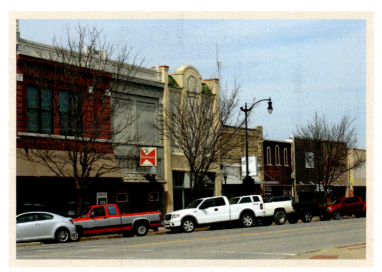

In 1910, Arkansas City had three downtown movie houses in addition to its opera house on East Fifth Avenue. In those silent film days, it was not unusual to stage vaudeville acts and other live entertainment in addition to showing movies. One of the popular houses of entertainment was the Gem Theater. In August 1910, it moved from West Fifth to a renovated building at 119 South Summit Street. It is shown in this photograph dated December 10, 1910. Today, the building houses the Cowley County Attorney's Office. (Past, courtesy LPR.)

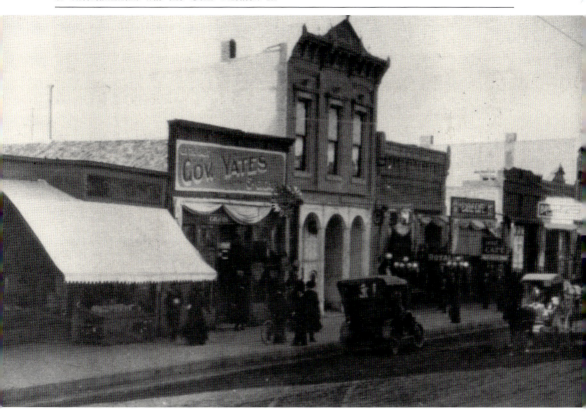

Downtown

A former shipbuilder named Samuel C. Smith built a hotel at 201 North Summit Street called the Gladstone in 1886. Stonecutters Joseph Bossi and Antonio Buzzi supervised the construction. The historical building served as an academy and then as a sanatorium in the early 1900s. Remodeled in 1923, it again became a hotel. In 1928, it was named the Elmo. The A.B. Baker family operated the Elmo from 1960 until the mid-1970s. It was razed in November 1985 after a fire in 1980 despite public protests. (Past, courtesy SRL; present, courtesy LG.)

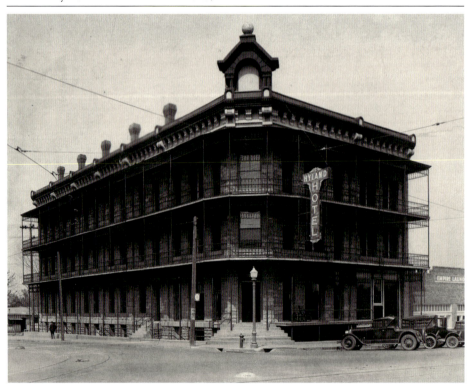

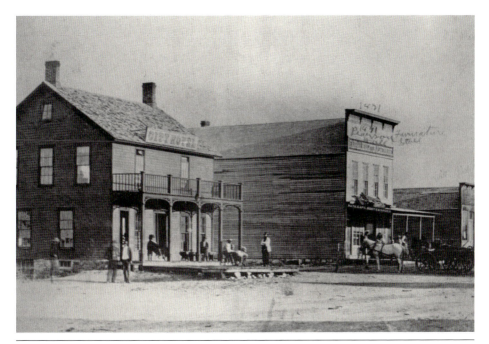

This c. 1873 historical photograph shows downtown Arkansas City. The City Hotel, at left, was also called Woolsey's Central Hotel. It was located where the Osage Hotel building now stands, on the northeast corner of Central Avenue and Summit Street. Also shown, directly across Central Avenue to the south, are other wood-frame buildings, including one labeled the Farrar, Houghton, and Sherburne stores. It perhaps was also the Pearson Furniture store in 1871, as a handwritten note on the photograph says. Today, the towering Osage Senior Apartments building replaces the old hotel. (Past, courtesy SRL; present, courtesy LG.)

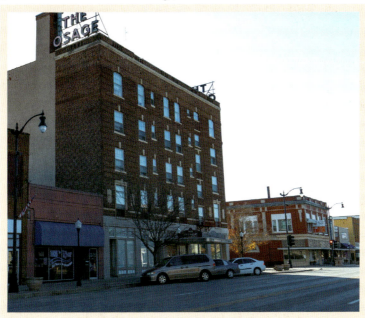

Downtown

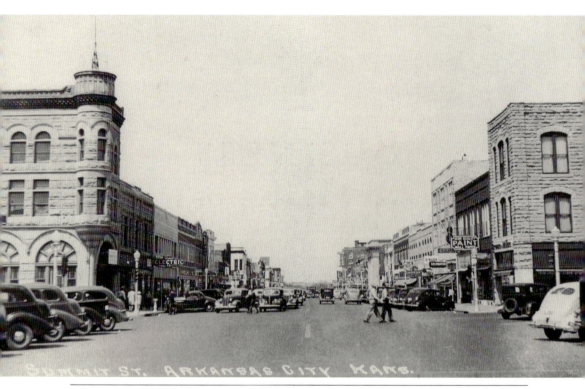

The vintage postcard shows a busy downtown scene in the 1940s. About nine months before the United States entered World War II, the retail merchants of Arkansas City appointed a committee to propose how the town could create more parking for an increasing number of automobiles downtown. Nearly two years later, the newspaper noted that even though local businesses were adjusting to the turbulent and uncertain atmosphere of wartime, 1942 had been a successful year for them. (Past courtesy, JZ; present, courtesy LG.)

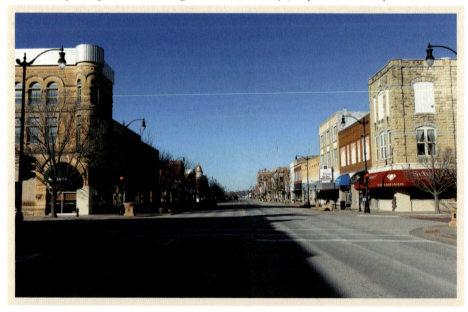

34 Downtown

CHAPTER 2

BUSINESS AND INDUSTRY

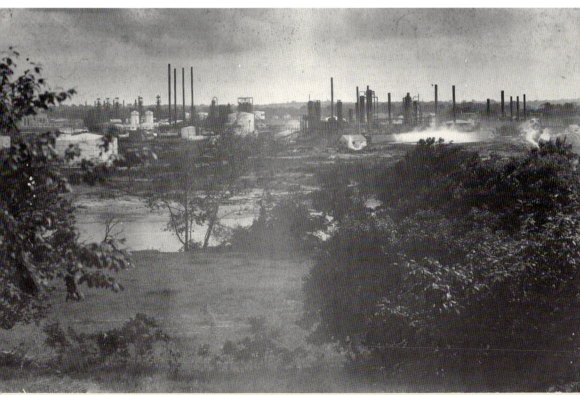

This undated photograph shows the Apco Oil Corporation refinery, formerly the Kanotex refinery. In 1917, Kanotex established its plant in Arkansas City. Civic leader Clyde Boggs held leadership roles at the refinery for many years. Apco bought Kanotex in 1953, and the refinery continued to thrive. It was sold in 1978 to Total Petroleum. Total closed the refinery in 1996. (Courtesy SRL.)

Early in 1950, Arkansas City lost its imposing landmark, the Santa Fe depot. Built in 1888, the redbrick structure featured a weather vane atop its roof and an elaborate Harvey House dining room inside. Prominent travelers who frequented the Harvey House included Wah-shun-gah, tribal chief of the Kaw Indians; American orator and politician William Jennings Bryan; and George W. Miller, the founder of the 101 Ranch. A new Santa Fe station just south of the former building (not shown) was opened in 1951 and remains in use by the Burlington Northern Santa Fe Railway.

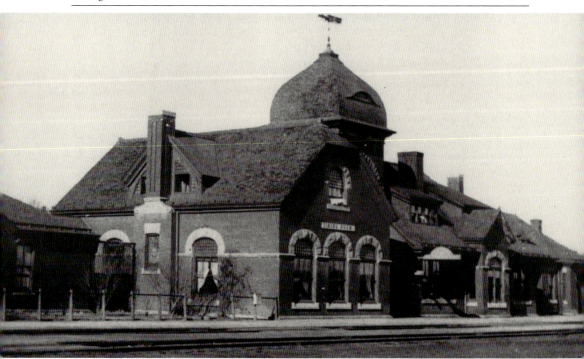

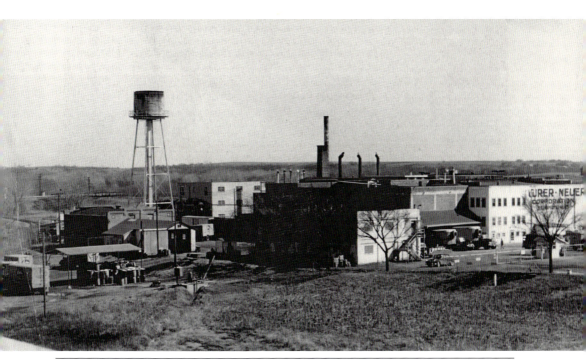

The former Ark City Packing Company site at the south end of town is now empty lots. Since 1903, it had been the site of meatpacking facilities run by a succession of owners. The historical photograph shows the plant between 1941 and 1960, when Maurer-Neuer operated it. Maurer-Neuer developed the Rodeo Meats line. In 1960, John Morrell and Company bought the plant. It was closed in 1990. Today, Creekstone Farms Premium Beef operates a state-of-the-art plant at the north end of town. (Past, courtesy CCHSM.)

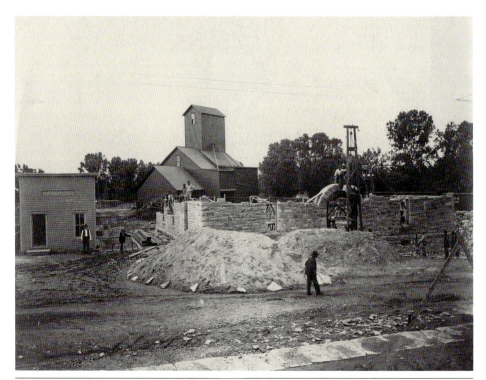

Construction of the four-story stone building housing the New Era Mill on West Madison Avenue began in 1899. A Kansas City company provided machinery for the plant. Within its first five years of operation, the plant's high-quality product, Polar Bear Flour, was being shipped throughout south-central Kansas and elsewhere in the United States and to Holland, Germany, and Scotland. Today, the original building is part of the ADM Milling's West Madison plant. (Past, courtesy CSLRM.)

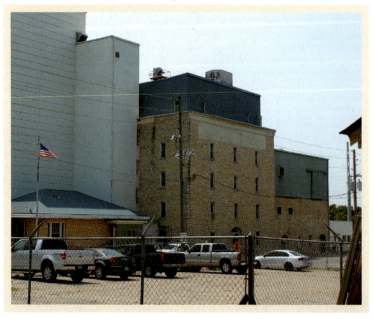

The New Era Mill is shown from South Second Street looking toward the stone building's main entrance on West Madison Avenue. A.J. Hunt founded the company in 1899. He began construction of a four-story facility that same year. After Hunt died in 1918, two Sowden brothers took over the New Era Mill. Four generations of the Sowden family ran the business in Arkansas City until the mill was sold in 1977 to the ADM Milling Co., which continues to operate the mill. (Past, courtesy CSLRM.)

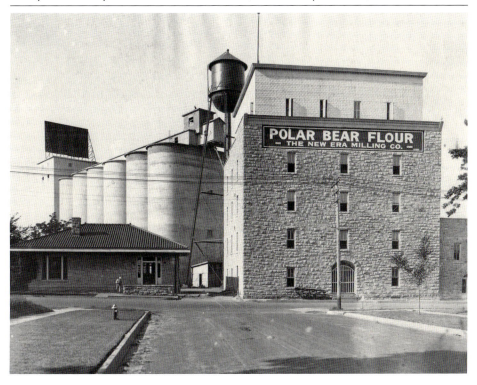

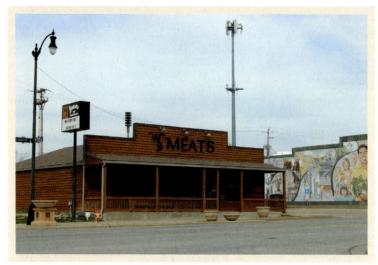

This historical photograph shows the former Syndicate Building at the corner of Summit Street and Jefferson Avenue, constructed in 1888. It was built by New York investors who teamed up with Arkansas City businessmen. From 1936 until 1986, Shanks Grocery and Market occupied the building. In 1986, it was demolished on the recommendation of a consulting engineer who said it was unsafe. In 2008, Mike Webb and Kelly Borror opened W.B. Meats in a smaller structure at the site. (Past, courtesy WK.)

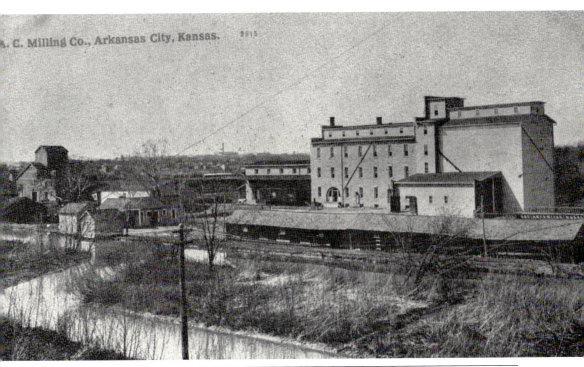

The Arkansas City Milling Co. has a history dating to the early 1870s when A.A. Newman and several other pioneers built a mill on the Walnut River in the northeast part of town. In 1878, Newman sold out to Searing & Meade. In the 1880s, a new facility in the southeast part of town was built. Its power was provided by a newly constructed canal built between the town's two rivers. Today, ADM Milling operates the East Mill as well as the former New Era Mill on West Madison Avenue.

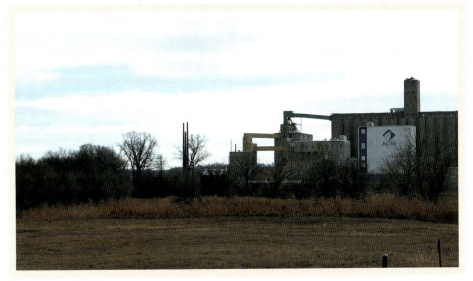

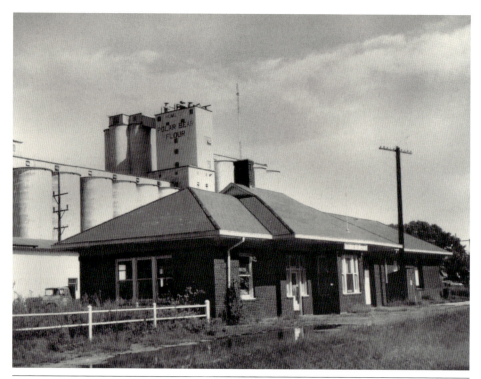

The first Midland Valley Railroad Company train entered Arkansas City in June 1906. The railroad built a large passenger depot west of the New Era Mill, shown in this 1966 photograph. By early in the second decade of the 1900s, the Midland Valley line ran from Fort Smith, Arkansas, to Wichita, following the path of the Arkansas River. The Midland Valley line through Ark City was purchased in 1966 by the Missouri-Pacific Railroad. The depot remained until a fire gutted it in 2013. (Past, courtesy KSHS; present, courtesy LG.)

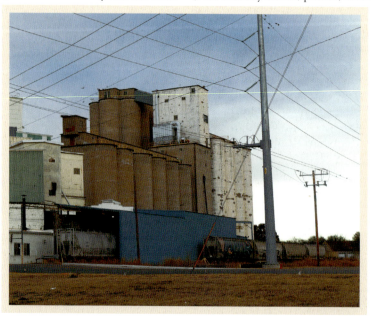

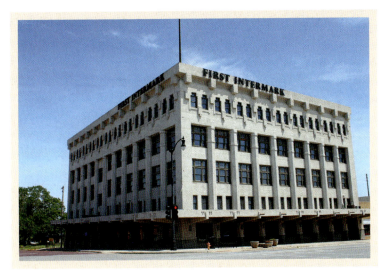

The downtown Arkansas City home of the Newman's Dry Goods Co. opened in 1917. Founded in 1870 by town pioneer and respected businessman Albert A. Newman, the business grew from a one-room operation to the oldest department store business in Kansas that was continuously run by the original family. It closed in 1988. A Western clothing store occupied the building for six years. Today, First Intermark Corporation, a locally owned customer retention marketing company, occupies the store.

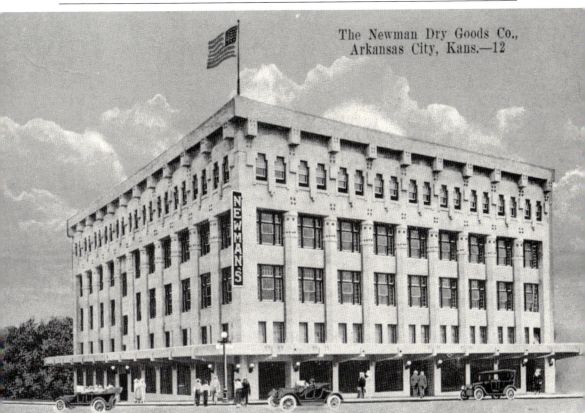

In 1888, J.A. Ranney founded a wholesale grocery operation in Arkansas City with one of the largest warehouses in the region, shown on this postcard. Ranney started the company in Ark City to supply settlers moving into Indian Territory, soon to become Oklahoma. W.H. Davis of Topeka went in with Ranney for two years but sold his share in the company in 1901. But the Ranney-Davis name was retained. The company grew steadily for years under Ranney family leadership until it closed in 1979. The building was razed and today is occupied by a Cowley County Community College parking lot. (Past, photograph by George Cornish.)

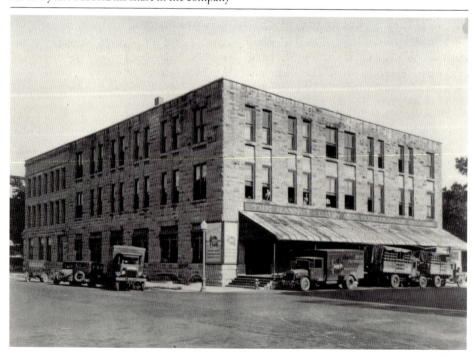

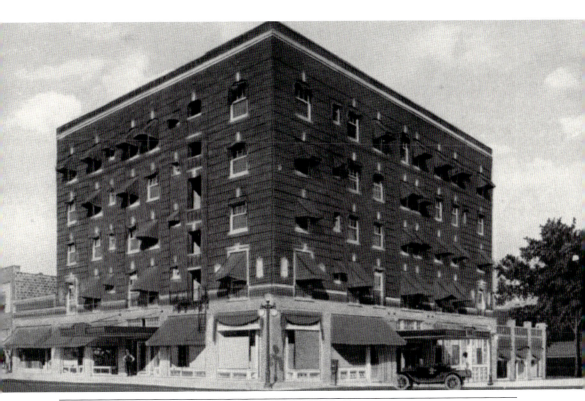

The Osage Hotel was built in 1920 at the northeast corner of Summit Street and Central Avenue. It replaced the town's first hotel, a small rooming house. The railroad transported building materials for the Osage, including bricks and Silverdale stone. The hotel soon became a favorite downtown meeting and dining place for citizens and business and civic groups. It housed visiting participants in the Arkalalah fall festival for many years, starting in 1928. Today, the former hotel operates as the Osage Senior Apartments.

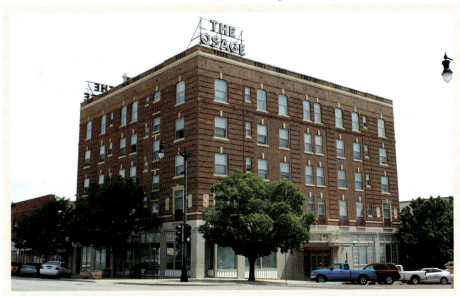

Business and Industry

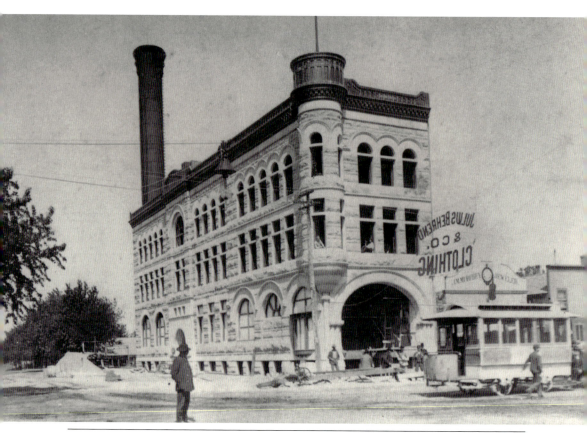

This 1890 construction scene on the northwest corner of Summit Street and Washington Avenue shows the nearly completed American National Bank building. The three-story rusticated stone building was home to several banks over the years. Various businesses, fraternal, and civic improvement groups occupied the upper floors. In 2009, upper-story renovation work was completed, including the installation of new windows that reflect the historical character of the building. Today, the building houses an Edward Jones financial services office. (Past, courtesy KSHS.)

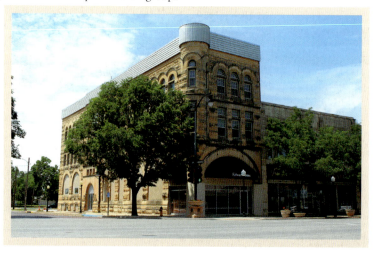

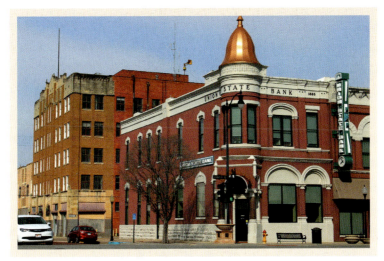

The iconic Union State Bank building at the corner of Summit Street and Fifth Avenue was constructed in 1883. It was first opened as the First National Bank. Within a decade, the bank experienced lean economic times and went through receivership in 1893. Known as the Union State Bank since 1898, the bank prospered and was expanded. Since 1956, the Docking family has controlled the bank. Kansas governor Robert Docking was bank president from 1958 to 1982. Today, Bill Docking, the late governor's son, is the bank's chairman of the board.

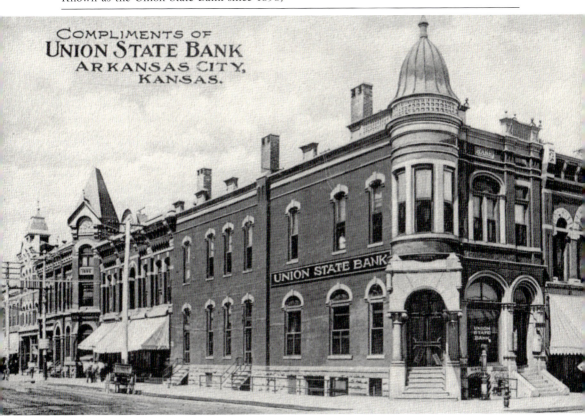

This image shows business buildings on West Fifth Avenue that stood there from around 1890 until 1929. All but the bank building was razed to make room for a five-story office structure that remains standing today. The postcard view looks west from the northwest corner of Summit Street and Fifth Avenue. The spire-topped building, third from the corner, housed the Hill Investment Company at 112 West Fifth Avenue. The company invested in properties throughout the town and offered them for sale.

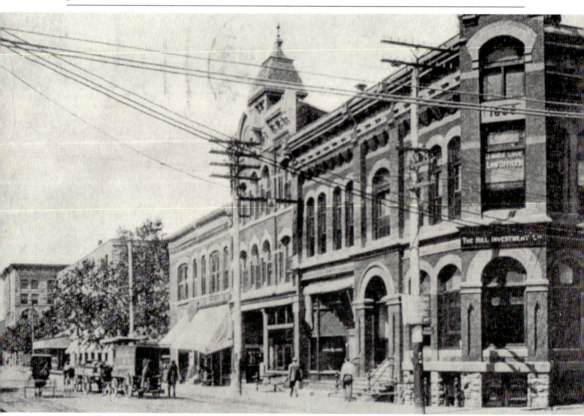

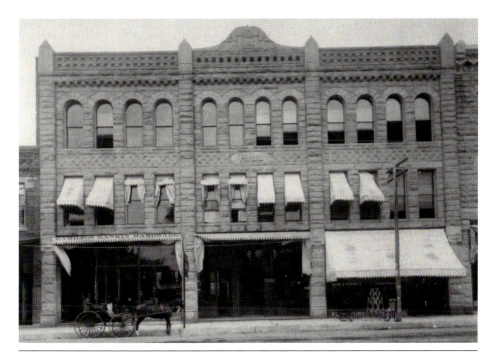

This historical photograph shows the 1889 Hamilton-Rankin Hardware Company building at 202–204 South Summit Street. In 1903, Harry Collinson bought out J.R. Rankin, and the store was renamed the Hamilton-Collinson Hardware Company. The structure was damaged by a fire in 1905 but was rebuilt the following year. It was destroyed by a massive fire on February 25, 1931. Today, the site is occupied by the Beekman and Zadie buildings. Venue 208, in the south portion of the Zadie building, is used as a meeting venue for community groups. (Past, photograph by William S. Prettyman.)

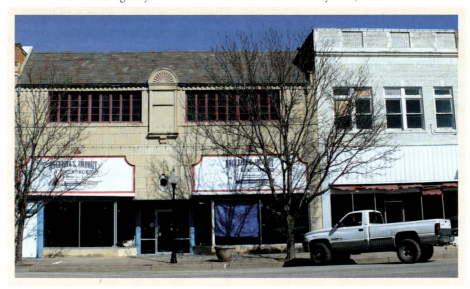

BUSINESS AND INDUSTRY

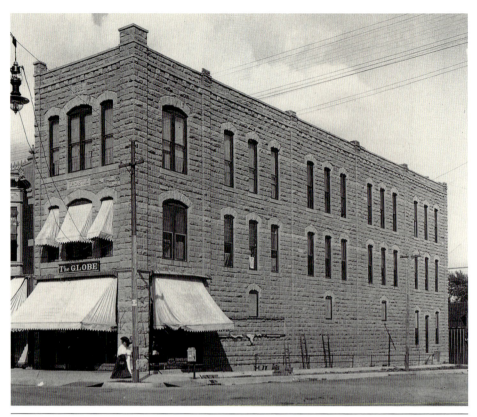

The 1889 stone building at 226 South Summit Street was known initially as the KP Castle building. The Knights of Pythias (KP), a secretive men's fraternal order, met on the third floor. Other businesses occupied space in the building, including The Globe, a women's clothing store, shown in the early 1900s. From 1999 until 2023, Lucas and Blanche Schmidt ran a jewelry shop business there. They moved their shop in 2023 to another structure on North Summit Street and put the historical building up for sale. (Past, courtesy CSLRM.)

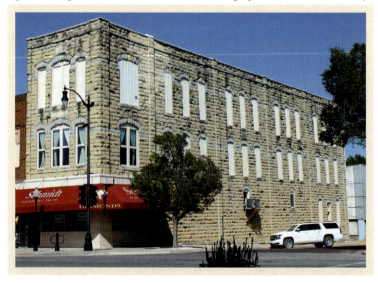

Various businesses operated in buildings on the west side of the 200 block of South Summit Street during the 1920s and 1930s. This historical photograph marks the "207" address above the White House Café. In 1925, the café received the Red Seal award from the state's hotel commissioner for quality service and food. Today, a hair salon operates at the 207 address, and Taylor Drug store occupies the three neighboring buildings to the right. (Past, courtesy DS.)

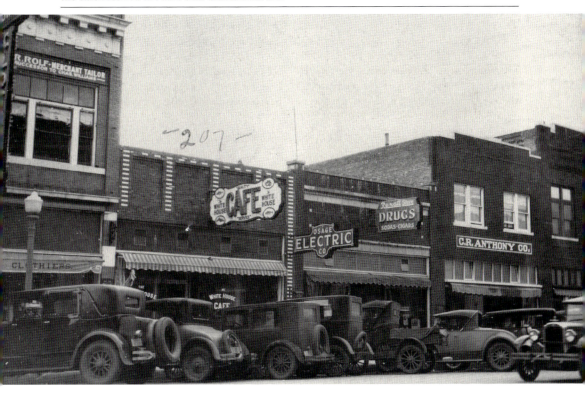

Business and Industry

Kenneth Ross started his own insurance company in August 1942. Joe Bly went to work for him in 1946. Ten years later, the two men formed a partnership, Ross & Bly Inc., at 108 South Summit Street. Ross was president, and Bly was vice president. In 1969, Ross & Bly merged with another insurance company and moved to North Summit Street. Its former structure was demolished, and today, it is a walkway just north of the Burford building. (Past, courtesy SR.)

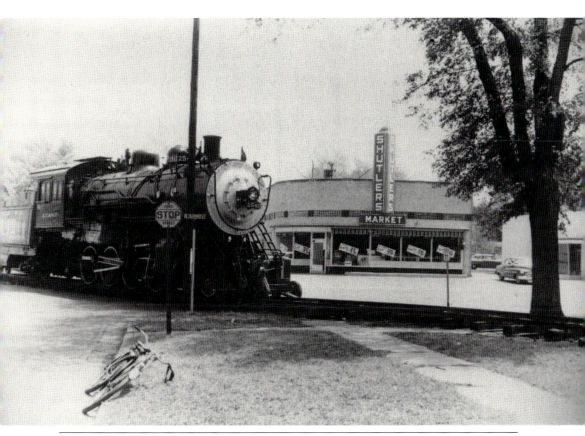

In 1955, an old Santa Fe locomotive was moved from railroad tracks several blocks away to Wilson Park, at Summit Street and Birch Avenue. Across the street from the park is the Shutler Market building, constructed in 1939. It was the third supermarket opened in Arkansas City by two enterprising brothers, Harry and Wilbur Shutler. It operated for more than three decades. Today, it is occupied by an insurance business, United Agency Inc. (Past, courtesy LPR.)

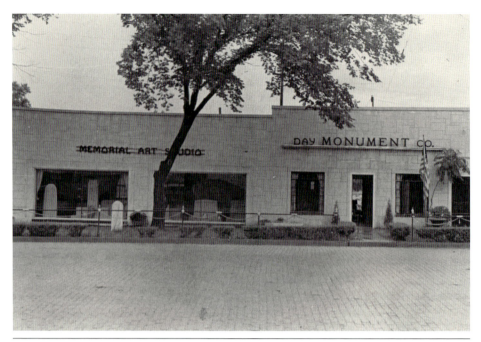

Day's Monument Company, originally named the Day's Monument Works, was established in 1919 at 907 South Summit Street. B.R. Day and his son Lotus Day were the founders and owned the building shown in this historical photograph. Around 1925, they expanded the building to accommodate an enlarged workroom and showroom. It operated for nearly 90 years, producing engraved cemetery memorials made of high-grade marble and granite. Today, the Dawson Monument Company operates at the site. (Past, courtesy DS; present, courtesy LG.)

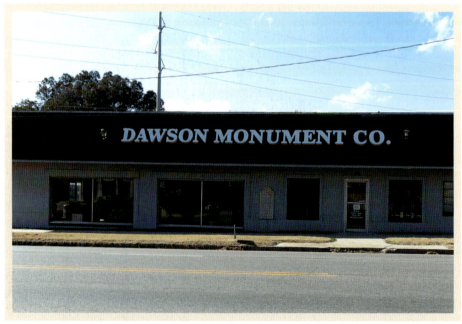

In 1907, Charles S. Beard opened a small machine repair shop on lots now occupied by city hall. In September 1910, he purchased a 40-by-140-foot building at 723 South First Street to meet increased work demand. The stone building previously had been used by the gas company. The Beard Foundry and Machine Works operation expanded over several decades. By 1940, it had produced cast-iron streetlight standards and manhole covers for towns throughout Kansas and Oklahoma. The shop was in business for 65 years, finally closing in 1976. (Past, courtesy SRL; present, courtesy LG.)

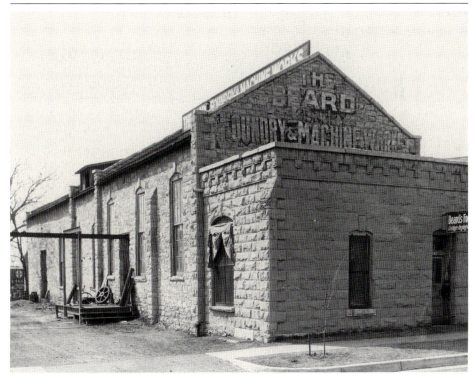

The 1880 Matlack Building was extended in 1887. At 201 South Summit Street, it is the oldest remaining building in the downtown historic district. Today, the building houses Taylor Drug, the latest in a series of drugstores that have occupied the space since the mid-1890s. Town booster Albert Clemente and his wife, Audine, ran a drugstore in the building from 1962 until 1983. The building was named for respected businessman and Ark City pioneer Stacey Matlack. (Past, courtesy JF.)

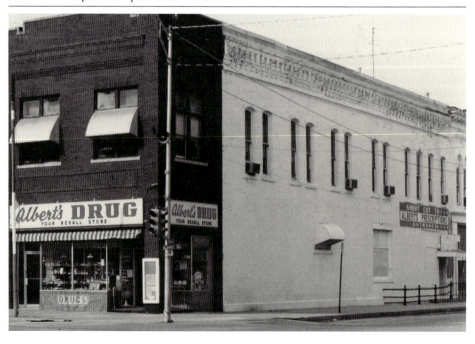

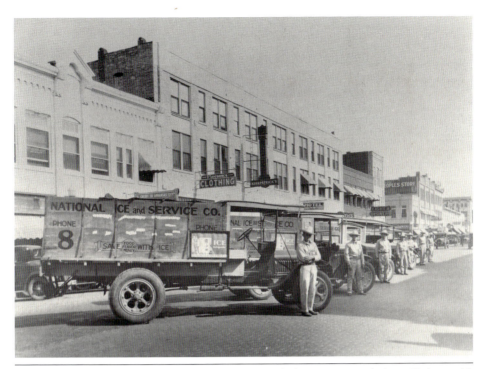

Dated around 1921, this photograph shows ice delivery men and their trucks on the east side of the 200 block of South Summit Street. Shown second from left is a three-story structure that was known as the Ormiston Arcade Building. It was destroyed in a 1931 fire and was replaced by today's Graves Drug Store building. The Arcade Building housed several businesses, including Kirkpatrick's furniture and shoe store. Before moving to the Arcade Building, E. Kirkpatrick conducted business in the McCowan Block building across the street, at 223–225 South Summit Street. He had moved there in 1905, when the building was new. He stayed in business until his death in 1920. (Past, courtesy KSHS.)

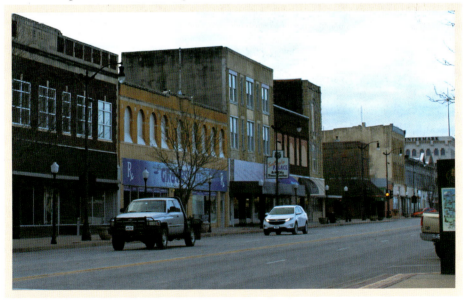

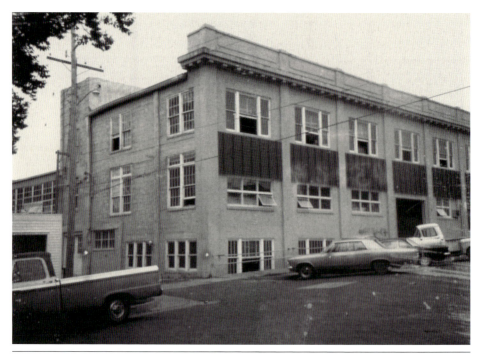

B.A. Tubbs founded Tubbs Motor Company when he came to Arkansas City in 1938 and bought the Ark City Motor Company. Tubbs had operated Chevrolet and Oldsmobile agencies for 18 years in other towns before moving here. In January 1949, he moved his dealership from North Summit Street to an enlarged sales and repair plant at Summit Street and Jefferson Avenue. It is shown on the Jefferson Avenue side. Tubbs Motor Company operated in Ark City for more than 50 years. Today, the building is operated as a mechanic and transmission shop. (Past, courtesy CCHSM.)

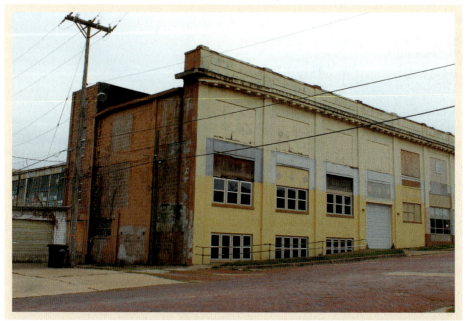

Rakie's Oil Company is a full-service gasoline station at 302 North Summit Street. The site has been occupied by filling stations since 1915. The historical photograph shows it when the Tybs Oil Company occupied the site, from the 1930s until it was sold to Raymond J. "Rakie" Smith in 1953. Today, Rakie's is owned by Mildred McGowan. In addition to pumping gas and checking under the hood for customers, Rakie's employees also provide vehicle maintenance and repair. (Past, courtesy Mildred McGowan.)

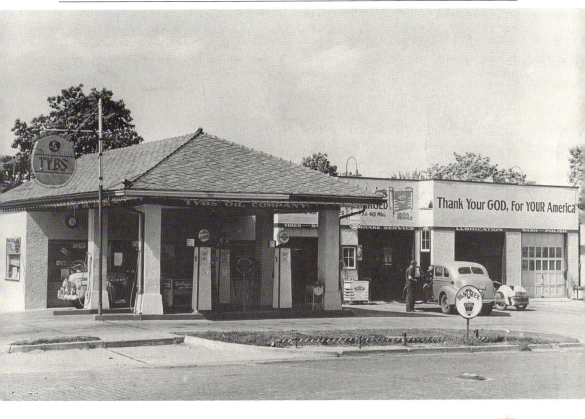

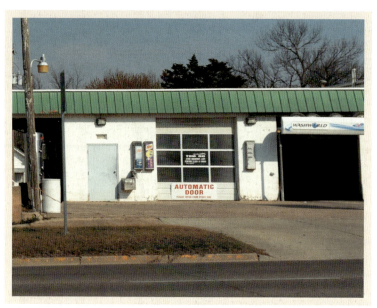

In 1915, E.W. "Ed" Grimes, shown in the historical photograph, opened the first gasoline service station in Arkansas City at 306 North Summit Street. It is near the northeast corner of Summit Street and Walnut Avenue, the site of the Rakie's Oil Company service station today. It was a 10-foot corrugated iron building with sidewalk pumps. Grimes's father and his son Harry operated the station while E.W. drove the oil wagon over a territory covering 20 miles in all directions from Ark City. (Past, courtesy KSHS.)

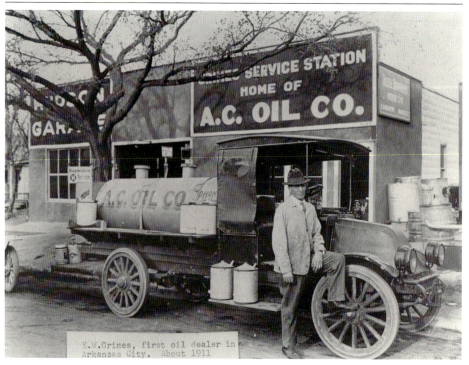

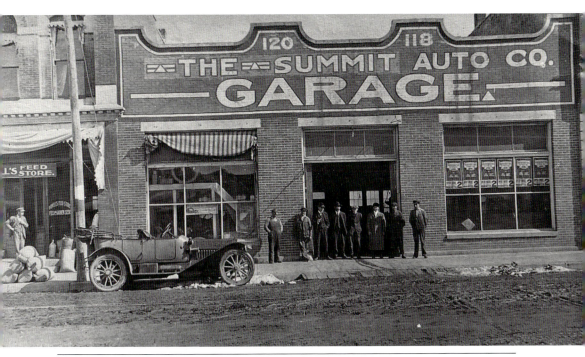

The Summit Auto Company, shown in this photograph dated 1914, was a downtown garage and auto repair shop. The shop at 118–120 North Summit Street also sold and repaired tires. In 1919, it was renamed Moody & Huff. It was listed as the Red Head Motor Company in 1930. By 1938, three auto-related companies shared the space. A chicken hatchery operated at the site from 1947 to 1952. Today, it is occupied by a law office and a health clinic. (Past, courtesy DS.)

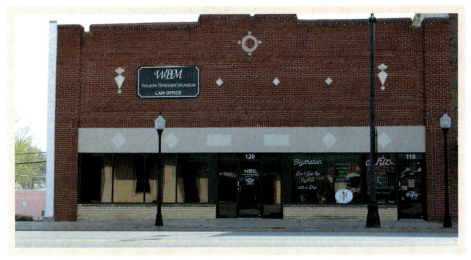

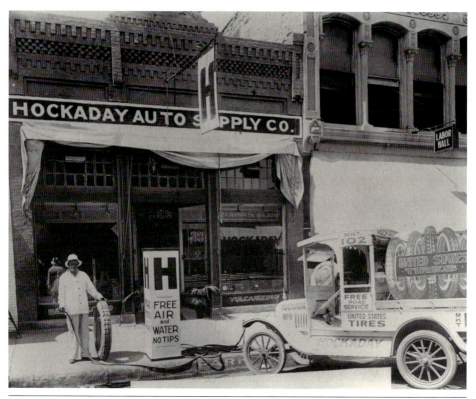

This historical photograph shows F.W. "Woody" Hockaday on the sidewalk in front of his auto supply company. A Wichita motor car accessory dealer, Woody opened a tire service and car accessory shop in 1919 at 112 South Summit Street, where the Burford building stands today. Hockaday teamed up with D.V. Burton to offer customers, at a time when automobile travel was relatively new, curbside and roadside service. (Past, courtesy KSHS.)

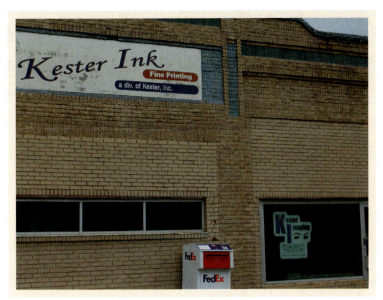

John A. Griffith founded John's Auto Body Shop at 209 North Summit Street around 1961. He is shown in front of the shop in the early to mid-1960s. After serving in World War II, Griffith moved to Arkansas City. He learned the automobile upholstery and body shop trade from two local mentors, Red Derry and Monk Bowker. Griffith died in December 1965 at age 50. Today, Kester Ink occupies the former shop building. (Past, courtesy VP.)

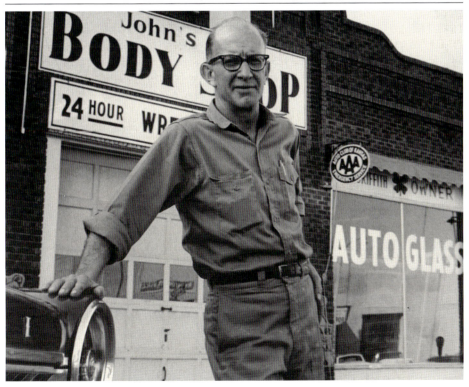

This 1953 postcard shows the former St. Louis–San Francisco Railway depot at the corner of Chestnut Avenue and Sixth Street. Construction of the depot began in 1912, and it was put into service in 1914. The Frisco was the second railroad to arrive in Arkansas City. It entered the town through a predecessor line in 1886. The first railroad to arrive in Ark City was the Atchison, Topeka & Santa Fe in December 1879. The Frisco served Ark City until 1980, when it merged with the Burlington Northern Railroad.

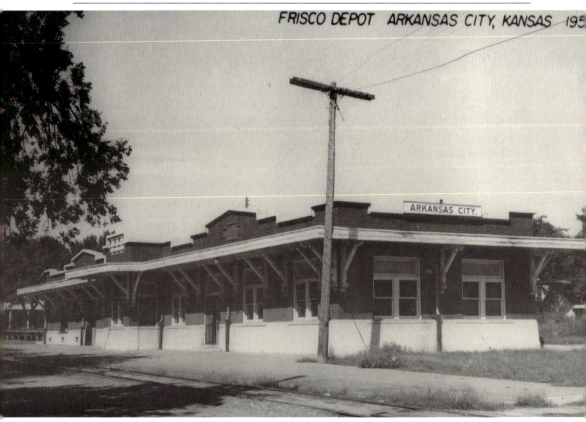

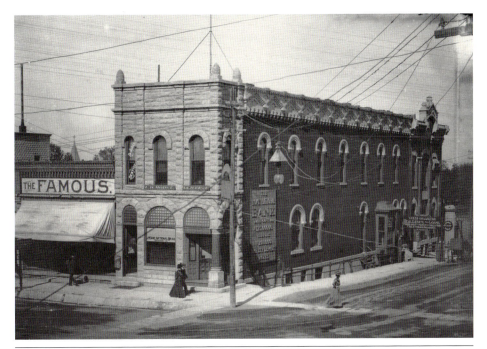

A new Home National Bank building at Summit Street and Fifth Avenue opened ceremoniously in June 1917. Founded in 1888, the bank was named Home National after a national charter was issued in December 1890. The new bank replaced a former brick building, shown in this vintage image by an unidentified photographer, constructed in the early 1890s at the same site. The building also housed professional offices in upstairs spaces. Home National closed in July 2010 when it was acquired by RCB Bank.

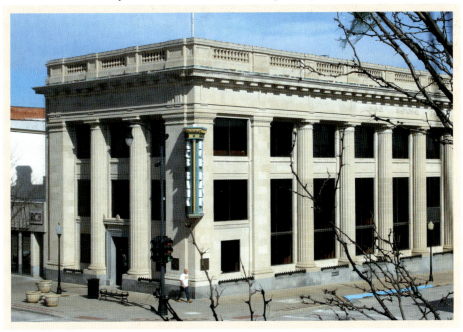

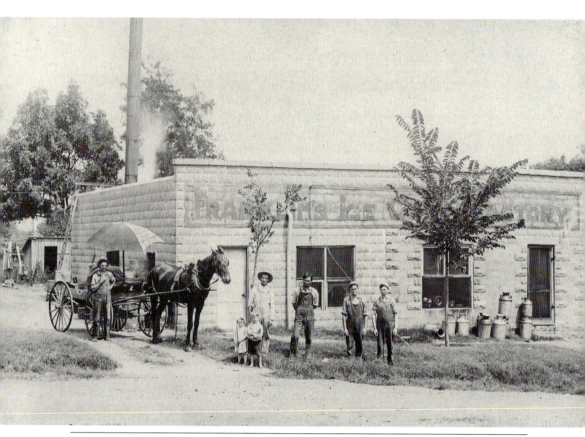

Around 1906, A.V. Franklin built an ice cream plant in the 400 block of North C Street and named it Franklin's Ice Cream Factory. The ice cream produced at the plant became popular, and the business grew. By 1913, Franklin ice cream was being distributed to customers beyond Arkansas City to surrounding towns. Franklin ran the plant until around 1922, when he opened a grocery store on North Summit Street. The factory was converted into a residence. It is occupied as such today.

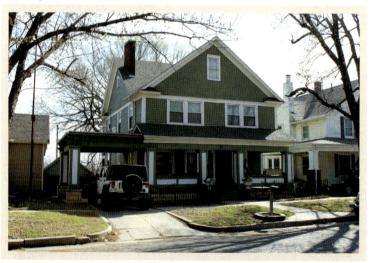

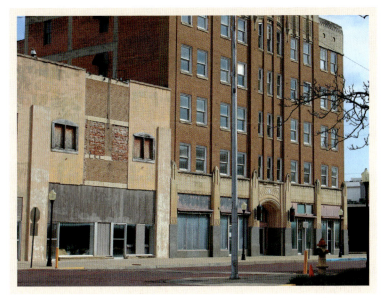

In May 1931, Spanish-American War veteran Starr Wetmore opened the Starr Theatre in the 100 block of West Fifth Avenue. It is shown on the left in this historical photograph. The movie theater was popular with children and catered to families. The Starr closed in November 1940 but underwent an extensive renovation and was reopened in January 1950. It closed for good several years later. Today, the building, which is adjacent to the former A.C. Office Building, is vacant. (Past, courtesy SRL.)

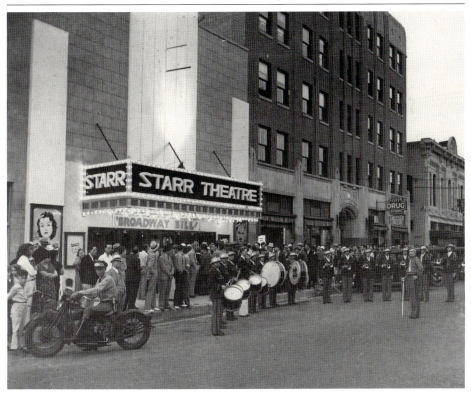

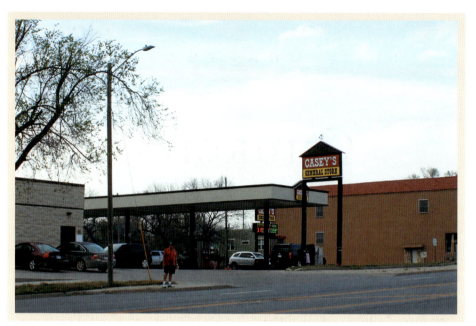

This historical photograph was taken during the early to mid-1940s. Two successful companies operated at the corner of Summit Street and Madison Avenue from the 1920s through the 1950s. Constructed in 1924, the building at right was occupied by the Oklahoma-Kansas Wholesale Grocery Company. On the left was the TempRite Manufacturing building. It made metal soda pop coolers for Coca-Cola and other customers. In 1948, its name became Acton Manufacturing. The site today is occupied by Casey's General Store and gasoline station. (Past, courtesy CCHSM.)

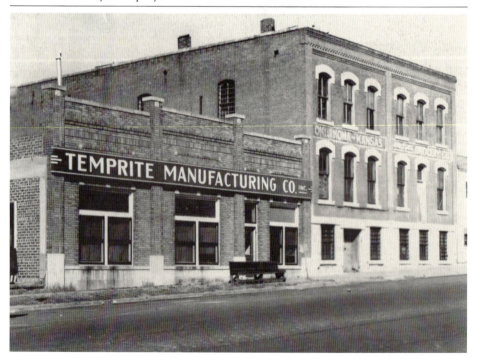

CHAPTER

3

CHURCHES AND SCHOOLS

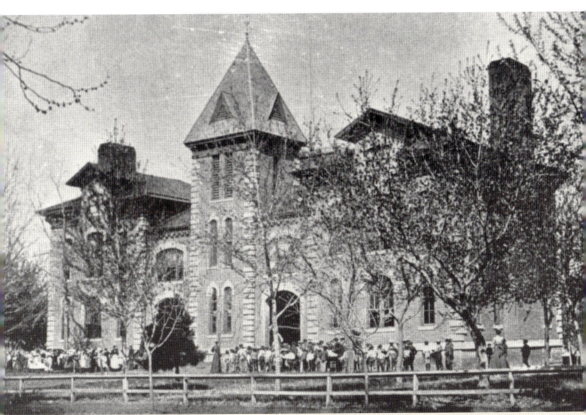

In 1874, a new brick and stone building was constructed in the 300 block of North B Street. Called the First Ward School, it originally was the common schoolhouse for elementary and high school students. Shown is the building after it was enlarged in 1888, and within a few years, it was used exclusively as an elementary school. The name of the school was changed to Roosevelt in the early 1920s. (Courtesy TN.)

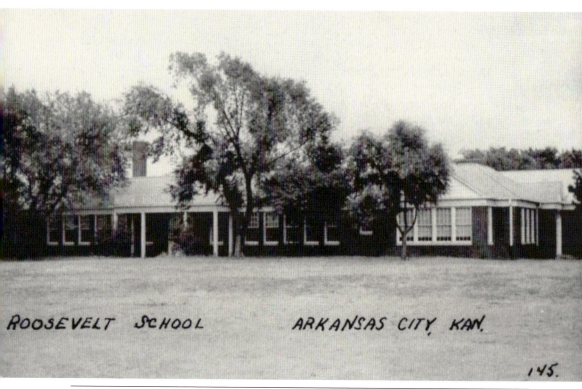

These photographs show Roosevelt Elementary School, 300 North B Street, as it looked when it opened in 1932 and as it appears today, after expansions. It replaces the old First Ward School built on the same site in 1874—the first ground that was set aside for a permanent school in Arkansas City. The two-story First Ward School held classes for both elementary and high school students. The old school was razed in 1932. It had been renamed and replaced with this redbrick building, pictured then and today. (Past, courtesy CCHSM.)

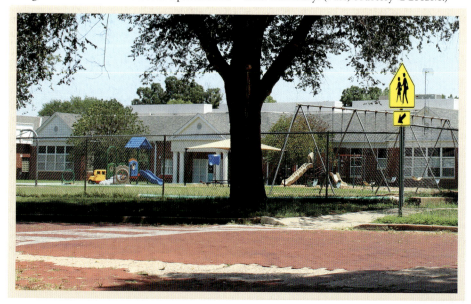

Frances Willard was one of four original elementary schools serving Arkansas City. Built in 1884 at Fourth Street and Walnut Avenue, it was constructed of locally quarried Silverdale stone. Formerly it was known as the Fourth Ward School and referred to as Central School because of its central location in town. In 1955, it was replaced by the current school building, which was updated and expanded in the late 1990s. (Past, courtesy TN.)

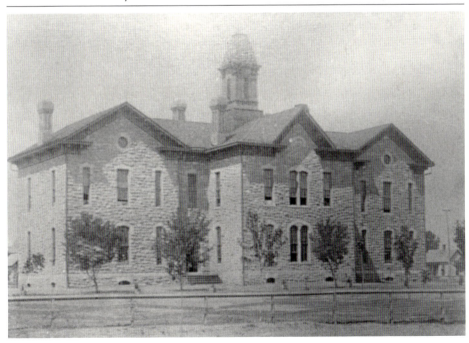

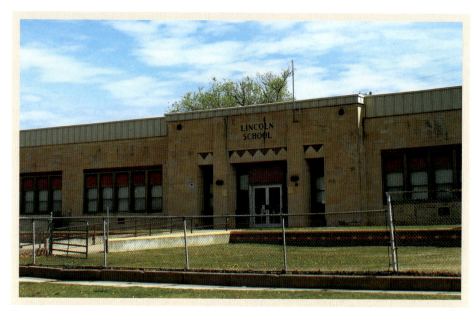

The Second Ward School, later named Lincoln Elementary, was built in 1886. Shown in this historical photograph, it was the fourth school erected in the 16-year-old town. This photograph was taken around 1919 after the school building was modified to include a two-room wing that faced west, adjoining the north-south wing. The two-room wing was built to help protect the playground visible from the front porch. The original school was razed in 1931 and was replaced by the one-story building that stands today.

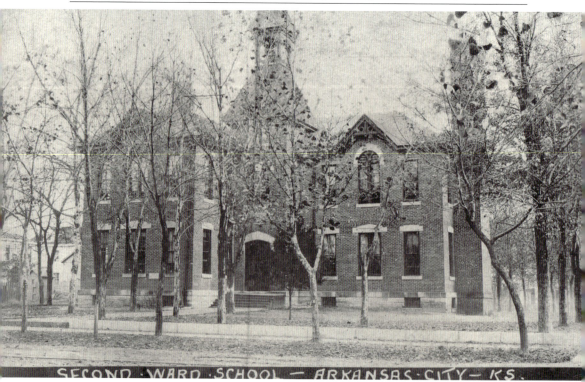

Churches and Schools

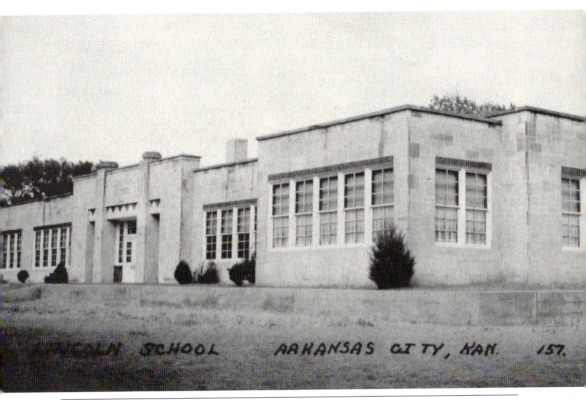

These photographs show the Lincoln Elementary School building that was constructed in 1931 at South B Street and Madison Avenue. It replaced the 1886 Second Ward School building at the same site, which was razed. The school was closed in 1991. From 1994 until 2017, the building housed a Head Start preschool, special education program called Lincoln PALS. In 2018, a Cowley County Health Center official expressed interest in establishing a clinic in the building. (Past, courtesy CCHSM.)

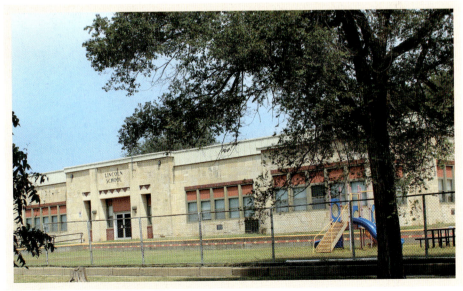

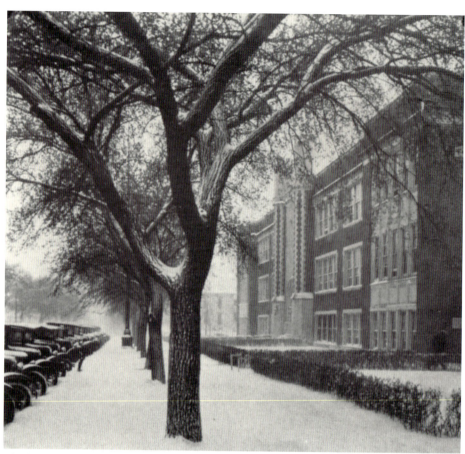

The former Arkansas City Senior High School served local students from 1922 to 1982. Its building in the 200 block of South Second Street featured the English Gothic design of the Tudor era. In December 1978, the school board approved the construction of a new high school in the north part of town rather than renovating the former school. It was torn down several years later. Today, Cowley College's Brown Center housing a theater and music classrooms is at the site. (Past, courtesy TN.)

A three-level manual training building on Third Street and Fifth Avenue, shown at left, was completed in time for classes in 1912. In 1918, an adjacent building, at right, was completed and the two structures were dedicated as Arkansas City Junior High School. A new junior high school—today's Arkansas City Middle School—opened in 1967 on East Kansas Avenue. Today, the former junior high school site is a part of the Cowley College campus. (Past, courtesy SRL.)

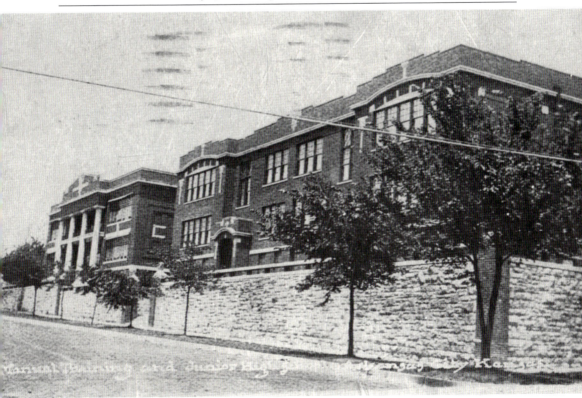

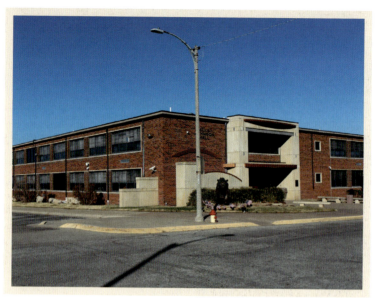

Groundbreaking for Arkansas City's junior college building occurred in 1950. Located at Fifth Avenue and Second Street, the new classroom and administrative building and an adjacent vocational shop building (not shown) opened in 1952. For 30 years, since the college was founded in 1922, classes were held in the basement of the former high school. Today, in addition to its main campus in Arkansas City, Cowley County Community College has multiple campuses and education centers in south-central Kansas. (Past, courtesy CCHSM.)

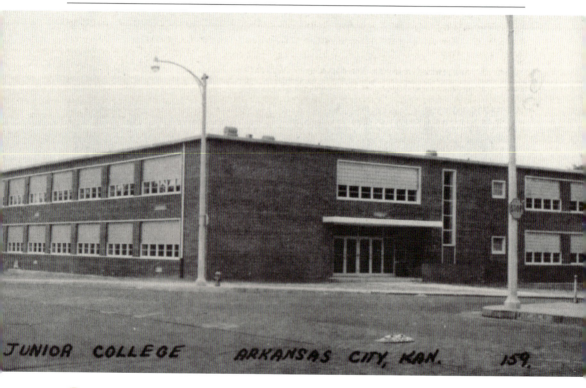

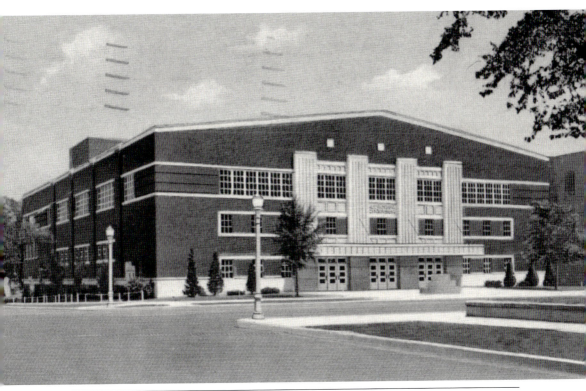

A new auditorium-gymnasium at Second Street and Fifth Avenue officially opened at the start of the annual Arkalalah fall festival in 1936. An $81,000 Works Progress Administration grant helped fund the building. The local school district owned and used it for high school and junior college athletic events, graduations, musical performances, and Arkalalah ceremonies. Cowley County Community College purchased the building in 1981 and in 1986 renamed it for longtime college administrator and athletic historian W.S. Scott.

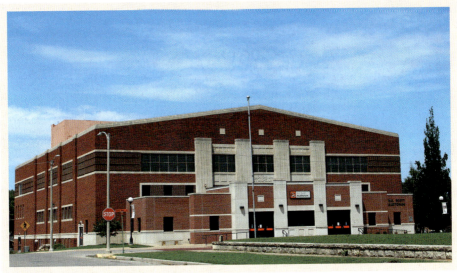

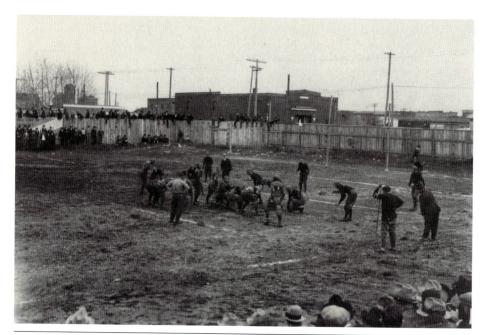

The Arkansas City High School football team played its first game at Curry Field in October 1920. The field was built over a slough area and dumping ground just south of Paris Park. The field was officially named for longtime football coach and athletic director Amos Curry. Since 1923, he had directed the development and maintenance of the field. The field was replaced in 2010 by a new facility next to the high school on Radio Lane. (Past, courtesy KSHS.)

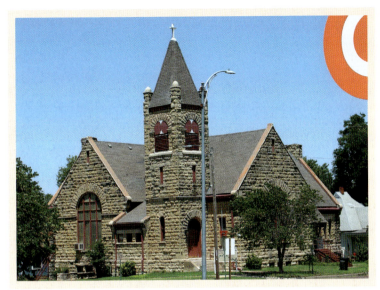

Construction of the Pilgrim Congregational Church began in 1891 and was finished in 1893. Several of Ark City's founding fathers were Congregationalists. Among them were A.A. Newman, Lyman Beecher Kellogg, and Henry Brace Norton. Built of sandstone with limestone trim, the church features a bell tower 78 feet high. In 1949, it became home to the Nazarene Church and in 2002 the Vinelife Family Church. It was added to the National Register of Historic Places in 2005. (Past, courtesy CSLRM.)

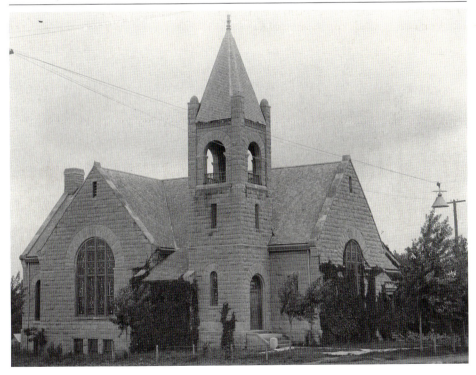

Churches and Schools

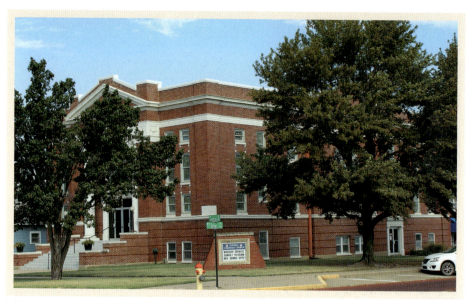

The Central Christian Church building was dedicated in 1923, two years after the cornerstone was laid. However, the church's history in the local community dates to 1877. The small congregation met outside of town its first five years before starting to hold services in a hall downtown and later in the First Ward School building. By 1886, the congregation built a frame church on Central Avenue just north of the current church's entrance on First Street. (Past, courtesy CSLRM.)

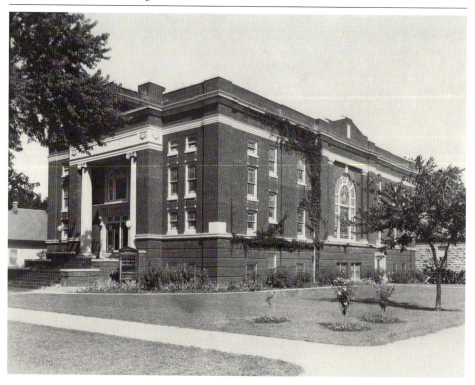

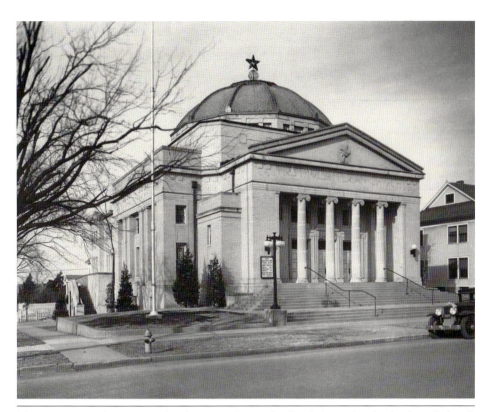

The First Presbyterian Church started construction on this domed sanctuary at 321 South First Street in 1913. Although the Presbyterian Church was first organized in Arkansas City in 1873, in its earlier years, it held worship services in several locations. Built in the Greek Revival style, the domed church was dedicated in 1915, with Dr. William Gardner as pastor. Today, the church appears much the same, but 1954 additions included a new two-story education wing and a small chapel. (Past, courtesy CSLRM.)

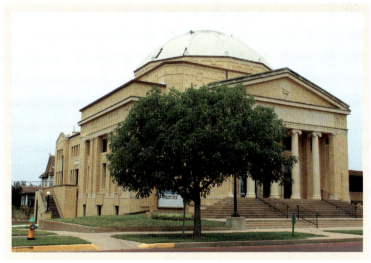

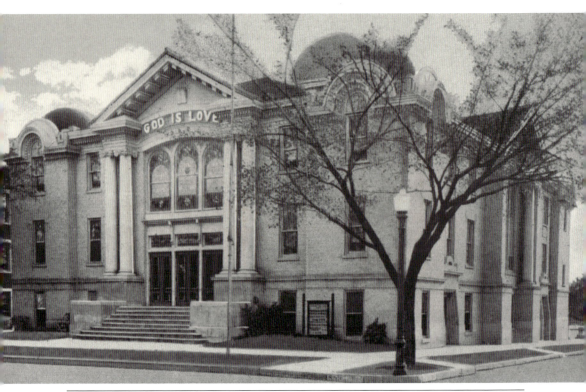

The first dedicated church structure for the Methodist congregation, on South Second Street, initially was used in 1875. In 1912, the cornerstone for the second First Methodist Church building was laid. It is shown on this postcard photograph. The church was the venue of the neighboring high school's first annual commencement in 1880. A new church with an educational wing was consecrated in March 1965. The former building site now is part of the Cowley County Community College campus.

The cornerstone of the new First Baptist Church of Arkansas City was laid in June 1927. But the church traces its history in Ark City to 1882. The first preaching services were held across from city hall in a blacksmith shop. The church's first building, a frame structure on East Central Avenue, was dedicated in 1885. Over the years, it was enlarged and remodeled. The current church was built at the same site. (Past, courtesy CSLRM.)

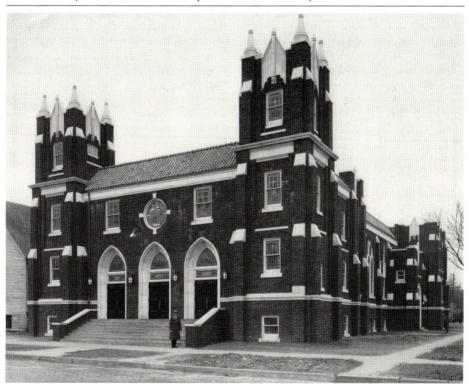

Churches and Schools

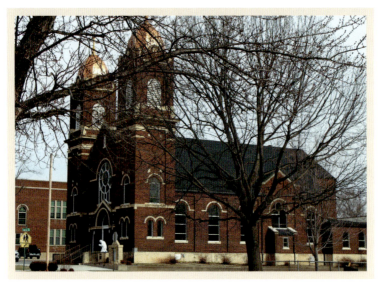

Parishioners of Sacred Heart Catholic Church on South B Street celebrated the 100th anniversary of their Romanesque Revival–style church building in November 2020. Bishop Carl A. Kemme of Wichita celebrated Mass on the occasion. The first Catholic church building in Ark City was a small frame structure constructed in 1886 on North A Street. Another frame structure on East Fifth Avenue served the growing congregation before the new church was built. (Past, courtesy Sacred Heart Church.)

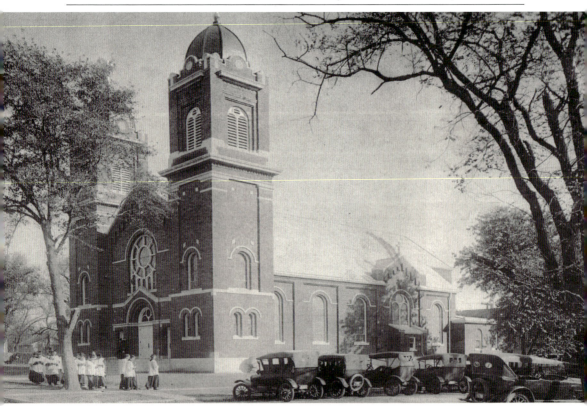

CHAPTER 4

Parks and Homes

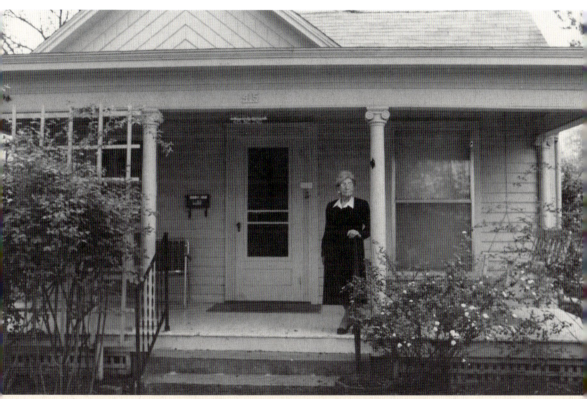

This 1993 photograph shows retired high school educator Edith Joyce Davis, age 106, in front of her house on North Second Street. She recalled the hot, dusty day of the Cherokee Strip Land Rush in September 1893. She saw her father and another man loading a horse-hitched buckboard in front of the house to go on the run. Edith lived at the house all her life. She died in December 1995.

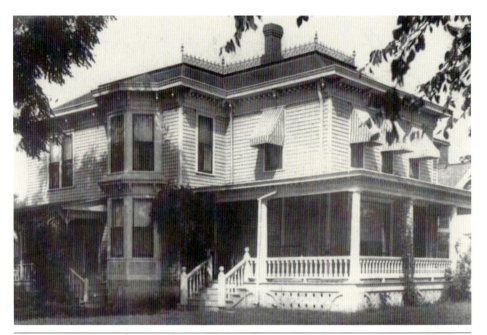

In the mid-1880s, William H. Curtis of Saratoga, New York, moved to town and built this house in the 300 block of North B Street. He lived in the house until his death in December 1893. In 1897, May Curtis married Robert B. McNaughton, then of Kansas City. He previously was a Santa Fe train dispatcher in Ark City. They lived at the North B Street residence for many years. Both died at the home, with May in 1940 and Robert in 1954. Today, the house is occupied by Arkansas City principal planner Josh White and his family. (Past, courtesy Josh White.)

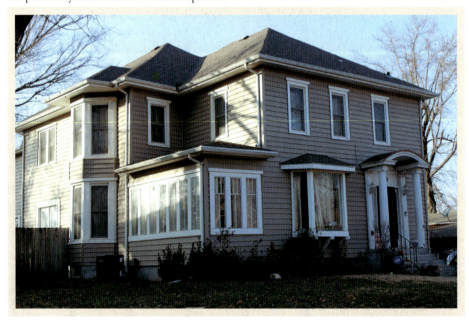

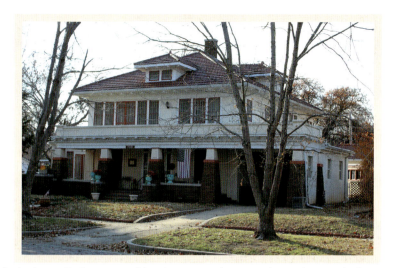

In 1914, Anthony Carlton, a wealthy Osage Indian tribal leader; his wife; and three daughters moved from Oklahoma to Arkansas City. Carlton built a luxurious house at 905 North Second Street and moved his family into the home in 1919. Carlton, who was well-known and respected in Ark City, died unexpectedly in 1927. Around 1946, the B.A. Tubbs family moved into the house and learned of the house's history. And so did Tim and Sandy Durham, who moved into the house in the early 2000s. (Past, courtesy Tim and Sandy Durham.)

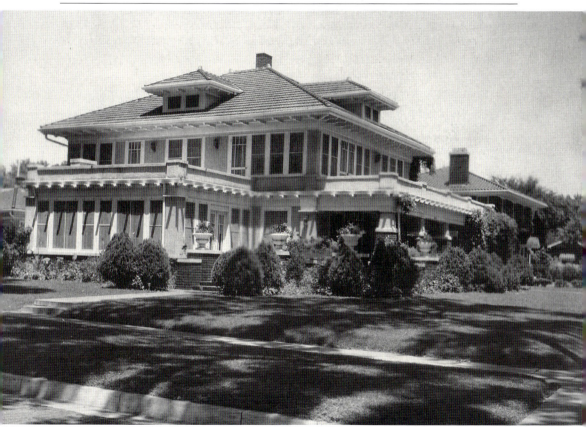

This North Fourth Street scene shows homes in a prominent neighborhood in the early 1900s. One of them, second from left, was built by Albert Denton, a highly respected businessman and banker. He was born in a log house southwest of town, built by his pioneer parents. After Denton's death in 1956, the house was used as a Red Cross center. From 1976 until 2007, it was operated as the Denton Art Center. Since 2007, the local arts council has occupied the newly renovated Burford building. Today, the Denton house is a private residence. (Present, courtesy LG.)

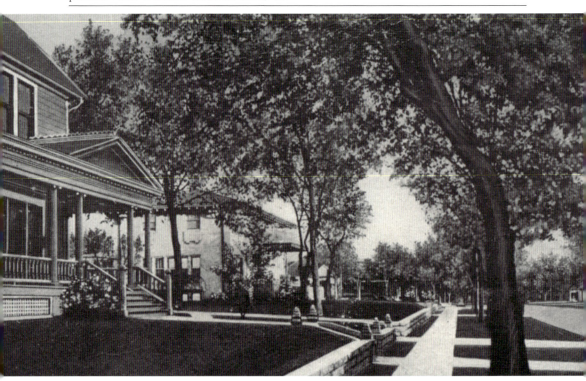

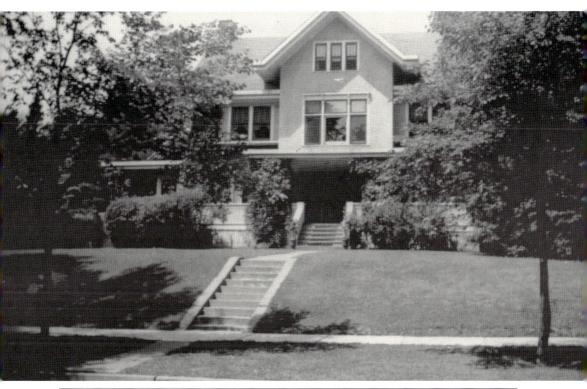

This house atop a mound in the 200 block of West Adams Avenue was the former First Presbyterian Church manse from 1932 to 1952. It is behind and west of the church, which is located on the corner of South First Street and Adams Avenue. The church purchased the manse in 1932 during the 25-year pastorate of Dr. Frederick Maier. Previously, the house had been the residence of Arkansas City attorney C.T. Atkinson. It is occupied as a private residence today. (Past, courtesy CCHSM.)

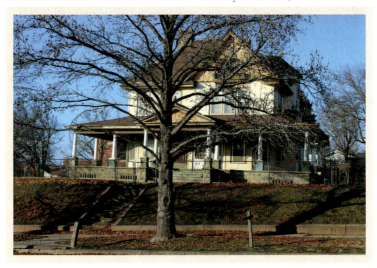

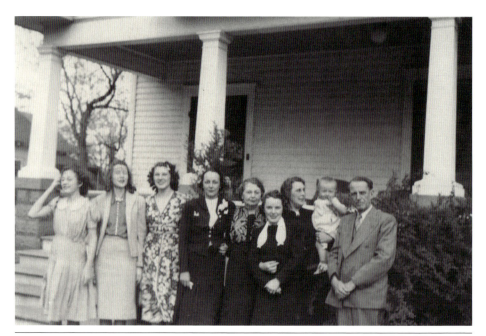

Wichita native William Patrick Stanton married Caldwell native LaVeta Reilly in 1907. In 1919, they moved to Arkansas City, where Stanton started the Oklahoma-Kansas Wholesale Grocery Company. Shown are family members in front of their two-story house at 302 North Second Street. The Stanton and Farrar families lived continuously in the house for around 60 years. Eleanor Stanton married William H. Farrar in December 1942. They moved their family into the house in the late 1950s. Today, the house is still occupied as a residence.

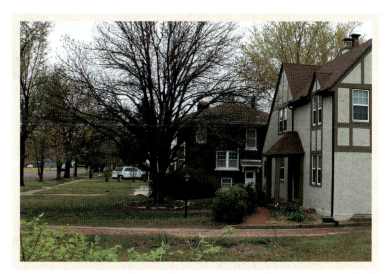

Famed Arkansas City–based photographer George Cornish photographed beautiful houses shaded by trees and set back from the street in the early 1900s. The view shown in the historical photograph is looking south from the north end of the 900 block of North Second Street, on the west side of the street. It looks much the same today.

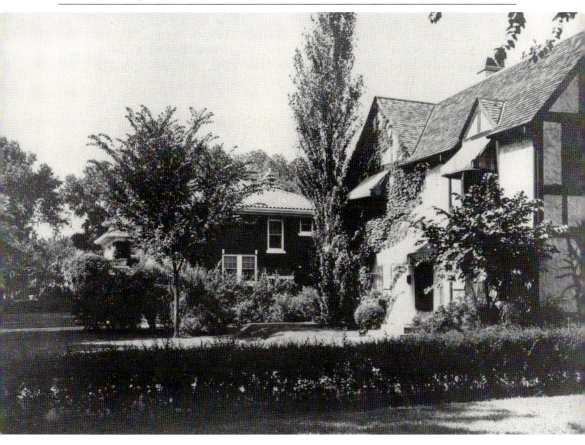

Parks and Homes

Former Kansas governor Robert Docking and his family lived in this house on North Second Street, pictured in 2002 and today, from the mid-1950s until 1967. That year, he moved with his wife, Meredith, and sons Bill and Tom to Topeka to serve his first of four terms as governor. Pictured on the front steps in 2002 are Susie and Lynn Woodworth, who lived in the house in the 2000s. Today, the house is still occupied as a residence. (Past, courtesy BD.)

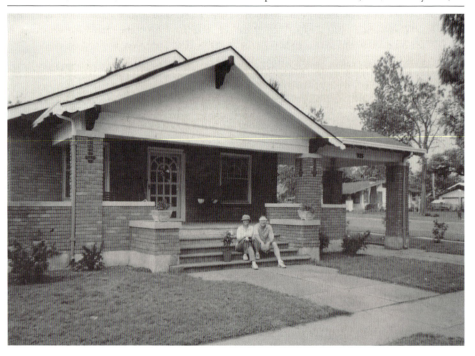

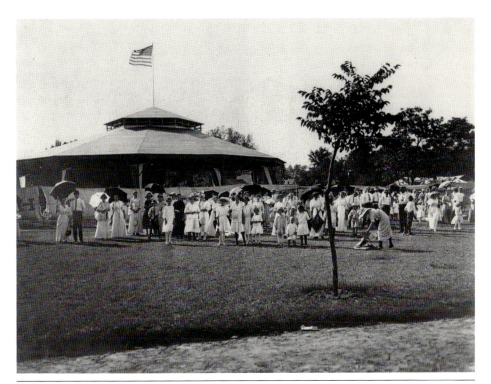

A June 1913 local newspaper story heralded the arrival of the Wilson Park rotunda. Built by a Bloomingdale, Illinois, company that specialized in making steel and concrete bridges, the structure was shipped to town by the Santa Fe Railroad. It was placed in the park on North Summit Street. The rotunda served, and still serves, as the venue for many city band concerts and festivals over the years. The Union State Bank sponsored a rededication of the renovated structure in 2008. (Past, courtesy KSHS.)

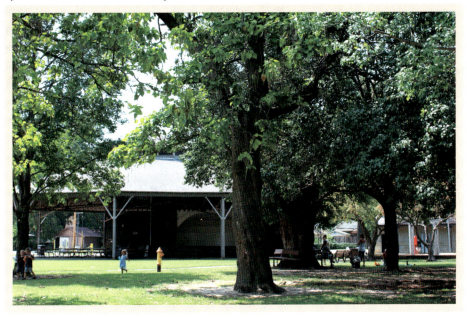

PARKS AND HOMES

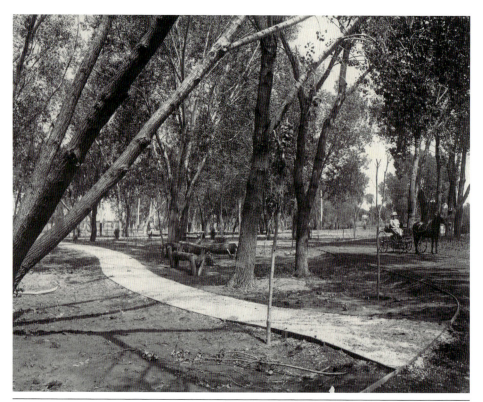

City councilman Ulman Paris conceived the idea of transforming swampy land west of downtown into a six-acre park. His idea came to fruition in 1909, when the tree-filled park named after Paris opened. An adjacent site was developed into a man-made lake, and a dancing pavilion was added in 1920. In 1942, one of the largest swimming pools in Kansas opened, replacing the lake. Today, the nine-acre park is considered the town's central park complex. (Past, courtesy CSLRM.)

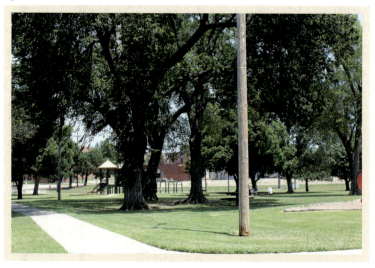

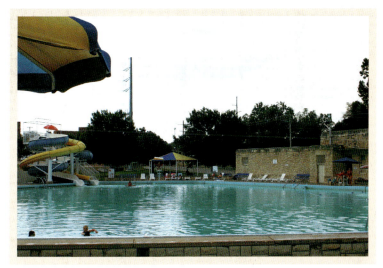

In the late 1930s, city officials submitted a proposal to the Works Progress Administration (WPA) to convert a lake at Paris Park into a swimming pool. The WPA approved a grant of nearly $75,000 for the $110,000 project. About 100 workers built the triangular-shaped pool, one of the largest in Kansas, and a stone entrance-bathhouse building. Opened in 1942, it remains a popular summer recreational spot, but a 2021 consultant's study suggested the pool be renovated or replaced. (Past, courtesy LPR.)

Discover Thousands of Local History Books Featuring Millions of Vintage Images

Arcadia Publishing, the leading local history publisher in the United States, is committed to making history accessible and meaningful through publishing books that celebrate and preserve the heritage of America's people and places.

Find more books like this at
www.arcadiapublishing.com

Search for your hometown history, your old stomping grounds, and even your favorite sports team.

Consistent with our mission to preserve history on a local level, this book was printed in South Carolina on American-made paper and manufactured entirely in the United States. Products carrying the accredited Forest Stewardship Council (FSC) label are printed on 100 percent FSC-certified paper.